70.00

...ege

...9 1T...: 01744 623552

last date shown below

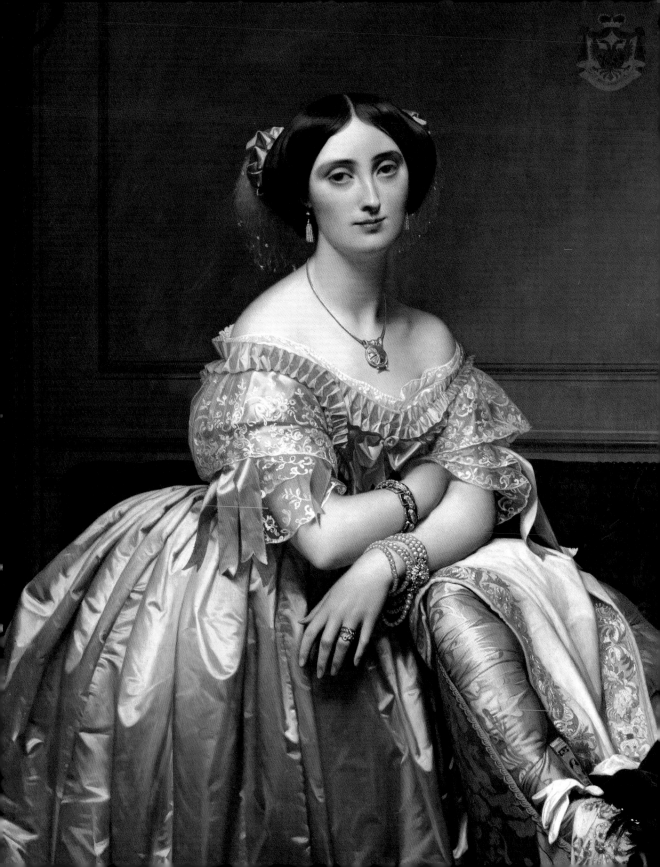

portraits

ROLAND KANZ
NORBERT WOLF (ED.)

TASCHEN

HONG KONG KÖLN LONDON LOS ANGELES MADRID PARIS TOKYO

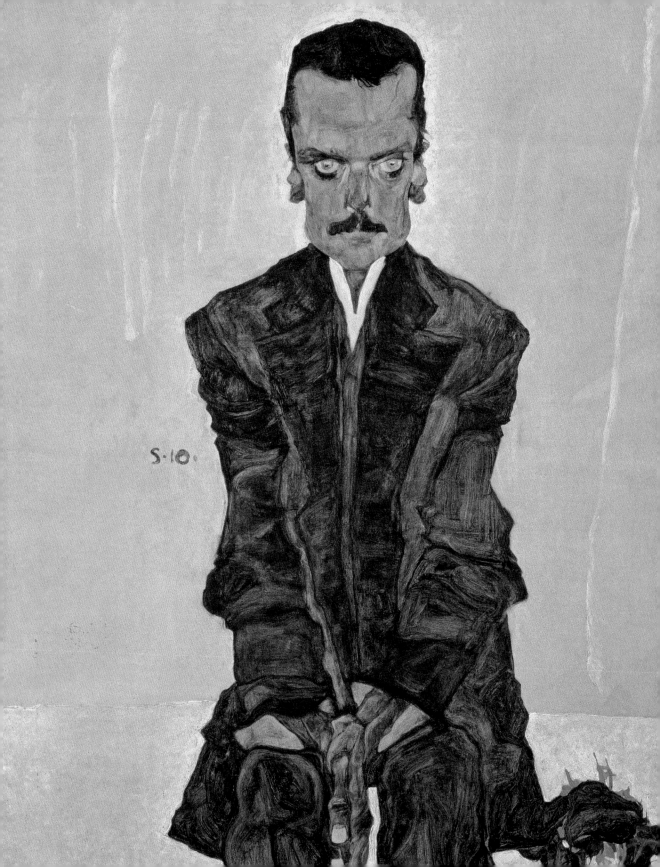

contents

ıdentity and ımage: Pictorial concepts of Portraiture

old Legends and Persistent myths

In the beginning (of art) was the portrait. That at least is how the creation myths of Antiquity saw it. Pliny the Elder, in Book 35 of his *Naturalis historia,* completed in 77 CE, made the gods of love responsible for the first portrait. The daughter of a potter named Butades from Sikyon, he writes, loved a man who was to go abroad. One evening Butades traced the shadow of his face which was cast by a lamp on the wall. He filled out the contour with clay, and thus created a lifelike portrait in profile, for his daughter a visible memory of her lover. There is much to be learnt from this legend. For a start, love was the motivation for all imitation, the driving force behind all art. The art theoretician Leon Battista Alberti, in his 1435 treatise on painting, had linked this drive with a self-related motif, namely narcissism. As we know, the myth relates how Narcissus fell in love with his reflection in the calm waters of a spring, according to Alberti the fount and origin of all portraits (strictly speaking, all self-portraits). Secondly, according to the Butades legend, the portrait marked the beginning of painting, because the human being was the noblest subject for art.

The myth of Butades, like that of Narcissus, reflects the basic "imitation of nature" view that has remained with the genre to this day:

there is a tension in the portrait between maximum likeness on the one hand and idealization for the purpose of show on the other. The maxim for portrait-painters since the 15th century has been that art has an obligation to copy nature. The aim of the portrait is a perfect likeness, such as Narcissus saw in his reflection. But narcissistic devotion to the self carries within it the fact of its own unfulfillability. For the "portrait" inexorably remains an illusion, existing only as an image on the smooth surface of the water. The merest breath of wind causes the image to blur, and the same happens when Narcissus reaches in to possess it, causing the object of his love to disappear. What remains is the yearning for the likeness.

The visual identity of sitter and image can be technically perfected, but never actually fulfilled. The driving force behind the production of portraits remained the narcissistic desire to "possess" one's own appearance. No wonder, then, that for all the unfulfillability, there was a wish to demonstrate the uniqueness of every human being by means of their portrait, as a kind of ID, so to speak. This culminated in the 18th century in the silhouette, whose Europe-wide popularity rested on the fact that the profile – as it were in distant recollection of the classical myth of origin – seemed to reproduce most reliably the features of an individual. By about 1800 devices for producing profile

1339–1454 — Hundred Years' War between England and France

15th century — Start of the Renaissance in Italy (Florence),
cultural transition from medieval to modern period, heyday of mercantile cities of northern Italy

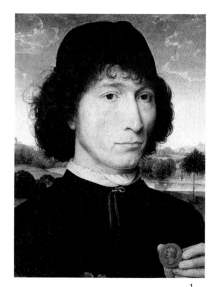
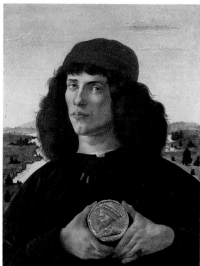

1. HANS MEMLING

<u>Portrait of a Young Man with a Roman Coin</u>
after 1480, oil on parchment on oak, 31 x 23.2 cm
Antwerp, Koninklijk Museum voor Schone Kunsten

2. SANDRO BOTTICELLI

<u>Young Man with a Medallion,
representing Cosimo the Elder</u>
c. 1474, tempera on wood, 57.5 x 44 cm
Florence, Galleria degli Uffizi

1

2

portraits were already being built, replacing the subjective hand of the artist by an incorruptible machine. Since then, continual thought has been given to how technical procedures might be used to produce a portrait as true to nature as possible. Faith in an objective likeness derives from faith in the omnipotence of "technical reproducibility" and the modern notion that visible reality is simply available. The new biometric techniques which seek to measure those features in a face which are unique to its owner also rest on the theory of the documentation of objective data and facts in the co-ordinate system of the countenance.

The question of whether there could ever be an absolutely objective portrait is at the same time a question about the possibilities of art. We have learnt that even photography is not "objective", and even for a reflection such an assertion would be psychologically questionable.

The actual practice of artistic portraiture creates a genuine reality. The observation of one's own reflection in a mirror involves an "uncertainty principle", which produces differences, often minute, in attitude and expression. In his 1908 portrait book, Wilhelm Waetzold simplified the conditions of this complex state of affairs by drawing attention to the three positions of those involved: as sitter, one wants the right note to be struck, as portraitist one wants to strike the right note,

and as beholder, one hopes to find that the right note has been struck. The manner of a portrait depends in every sense on subjective factors. This is true in the context of every technical process, in black-and-white and colour photography, in film and in video. The portrait thus puts across an "artificial figure". The representation aims at a higher unity of external likeness with the characteristic signs. This can be achieved not only by age, fashion, attributes, ambience, action and other accessories but also by the chosen technique, in painting for example the handling of colour and the brushwork, right down to what seem to be chance brushstrokes.

Consequently portrait art can be judged, as it has been for centuries, according to whether something has been added to the sitter, something which transcends the merely visual, in order to convey something of his or her individuality.

Person and character – picture and portrait

Even in Antiquity the art of portraiture was already enjoying a heyday. So why did it take until the 14th century for the genre to regain this status? The answer lies in the early-medieval Christian view of im-

1414–1418 — Council of Constance, end of Great Schism in Western church
c. 1450 — Invention of printing with movable type by Gutenberg

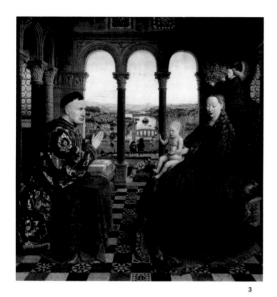

3

"while chancellor ROLIN – without having been ushered into the palace of the MADONNA by a patron saint – kneels silently before her in perpetual adoration, our view pervades through the hall along its central axis ..."
Otto Pächt, 1972

ages. In the Byzantine Iconoclastic Controversy of the 8th and 9th centuries, one of the issues was a distinction between the personal identity of the portrayed and what was actually displayed in the form of an image. An image can only manifest non-identity with a person. Accusations that images themselves possessed magic or physical properties could thus be refuted. What remained of importance, though, was the criterion of likeness. With respect to icons, theologians argued that the "prototype" was present by dint of likeness to the person. Accordingly, the two natures of Christ were, from the point of view of image-theory, kept apart, for it was only the likeness of His human nature that could be present in the image, not His divine nature.

An image has no essence of its own, let alone a supernatural or magical essence, but is merely the bearer of personal "character". The term "character" is of interest in this context, because in many languages it still helps to describe individuals in their deviation from the general. The Greek verb *kharássein,* which underlies the noun *kharaktér,* means "to engrave", especially signs, numbers and letters but also pictorial signs. The process of impression plays an important role here, and that applies also to painting. *Kharaktér* in Greek has this pragmatic value of "impression" in the sense of "shaping". By extension, this also refers to the distinctive quality of people or objects, the "charac-

teristic", as we say, by which they are defined. The "characteristic" is what is identified, and thus recognizable, by likeness. It is therefore important that the person be distinguishable from others of his or her type by reason of features particular to him or her. This too is contained in the term "character". It means unmistakability, and above all likeness between prototype and image. This is linked to faith in authenticity, for the image itself is proof, it is the assertion that the person thus represented looked like this and not otherwise.

And yet many older pictures felt it necessary to underline this assertion, adding the claim *ad vivum* (the picture was painted from life), or indeed the name of the sitter. In the construction-yard records of Villard de Honnecourt (c. 1220/30) the (French) terms *portrait* and *portraiture* are used. His understanding of *portraiture* consists not in vivid likeness, but in the product of the drawing process itself. The term "portrait" comes from the Latin *protrahere* ("to draw forth"), i.e. to draw forth the figure of objects or persons in such a way that they can be recognized at any time. The use of the word on the drawing is thus an assertion of reliability.

29 May 1453 — Ottoman Turks conquer Constantinople, end of Eastern Roman Empire
12 October 1492 — Christopher Columbus lands in America, ushering in great age of discovery

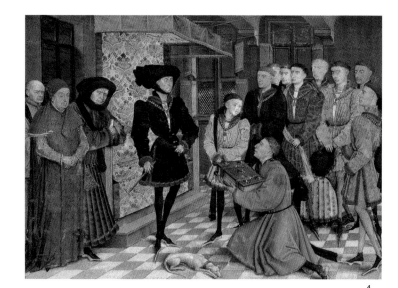

3. JAN VAN EYCK

<u>Madonna of Chancellor Rolin</u>
c. 1435, oil on wood, 66 x 62 cm
Paris, Musée National du Louvre

4. ROGIER VAN DER WEYDEN

<u>Jean Wauquelin submits his "Chroniques de
Hainaut" to Duke Philip the Good (detail)</u>
c. 1447, miniature, 43.9 x 31.6 cm
Brussels, Bibliothèque Royale de Belgique

4

тhe tasks of the portrait painter

In actual practice, the portrait painter had as a rule to follow the wishes of his client. One central motivation for commissioning a portrait in the first place was *memoria,* in other words handing down an image as a memento for future generations of the family, or in the context of a particular office. In funerary sculpture, the individual *memoria* is most obviously achieved through a portrait. In general, portraits should be credible witnesses to their age, conveying not just the appearance but also the social status of the person portrayed, the function of the image, or the context which endowed it with meaning in the first place. For art theoreticians, this gave the portrait a high status in the hierarchy of image genres, but also earned it much criticism. Painters were accused of merely pandering to the vanity of their clients and practising mindless imitation. A demanding portraiture, therefore, had to offer more than mere likeness. It needed a particular form of picture, a staging or *mise-en-scène* of the sitter, a virtuoso painting technique or intelligent content to give portraits the accolade of "high" art.

Portrait art has always been a part of history to the extent that it contains theoretical aspects and reflexions on human existence. The first clients were the nobility, the clergy, the patrician class. In the Netherlands, from as early as the 17th century, anyone with the necessary cash could commission a portrait. With the Enlightenment of the 18th century the link between portrait painting and a socially privileged client class was also relaxed in the rest of Europe. The turn of the 19th century is often seen as the transition from aristocratic to bourgeois portrait forms, in which the results of political emancipation and social change played an increasing role. It is clear, however, that the picture types and *mises-en-scène* remained constant until well into the modern period. Even photography in many cases used the well-tried patterns of presentation. Social distinctions became more complex, but the long-established poses and attitudes exist to this day in social role behaviour. Portraits are always concerned with private life and society, fashion and individualism, the characteristics of the individual in relation to the general.

Since the early Renaissance, specific patterns have developed as iconographic portrait types. They evince an astonishing constancy. It is worth pursuing these basic lines of development in modern portrait history.

1498 — Vasco da Gama discovers sea route to India around Africa 31 October 1517 — Martin Luther ushers in Protestant Reformation 1519–1555/56 — Habsburg world empire under Charles V

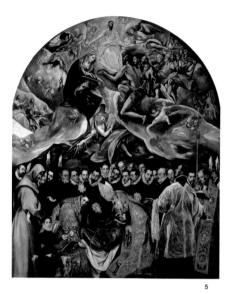

5. EL GRECO
<u>The Funeral of Count Orgaz</u>
1586–1588, oil on canvas,
480 x 360 cm
Toledo, Santo Tomé

6. DOMENICO GHIRLANDAIO
<u>Confirmation of the Rules of the
Order of St Francis (detail)</u>
c. 1485, fresco
Florence, lunette of the Sassetti
chapel in Santa Trinità

5

Donor portraits

The history of the donor portrait reaches back to Antiquity. Donors, captured in the act of donating, can appear in both worldly and sacred contexts. In the Christian sphere, the donor portrait is linked with devotion, and often intercession for the salvation of the soul in the next world. Among the most important donor portraits of the Middle Ages is the *Madonna of Chancellor Rolin* (ill. p. 8) by Jan van Eyck (c. 1390–1441). The panel was originally in the domestic chapel of the dignitary himself, before being hung in the family chapel as an epitaph painting, so that when mass was said, Rolin's depiction in an attitude of eternal prayer might guarantee a lasting supplication for the salvation of his soul. In an architecturally elaborate interior, Rolin kneels in prayer before an open book of hours. The theme is the spiritual contemplation of the Madonna and Child during private devotions. Van Eyck places the donor in an exclusive devotional chamber which he combines with an expansive view in the background: the combination can be related symbolically to Rolin and his political influence.

From the 15th century onwards, donors were also portrayed in groups. In Italy, the urban elites were distinguished by a particular urge for display. One aspect that illustrated their mutual rivalry was art patronage, which found its culmination in the decoration of family chapels. The Sassetti family provided an excellent example in Florence (ill. p. 11). Francesco Sassetti was one of the most important partners in the Medici bank, and belonged to the inner circle of acquaintances of Lorenzo de' Medici ("the Magnificent"). A family chapel for the Sassetti family was designed as the visible expression of this position, and between the years 1482 and 1485 Sassetti had it decorated with frescoes executed by Domenico Ghirlandaio (1449–1494). The theme of the lunette picture is the confirmation of the rules of the Franciscan Order by Pope Honorius III. In reality this conformation of the rules took place in Rome, but Ghirlandaio, doubtless on Sassetti's instructions, transferred the event to Florence. Sassetti is depicted alongside Lorenzo de' Medici, demonstrating his status. The integration of the sons of the two families is intended to show that the close links between the two families would continue into the future. The scene with St Francis and the pope serves as an historical background to enhance the aspect of display in the portrait.

1527 — Sack of Rome by imperial troops November 1534 — Act of Supremacy makes Church of England independent of Rome

1543 — Copernicus proposes heliocentric universe

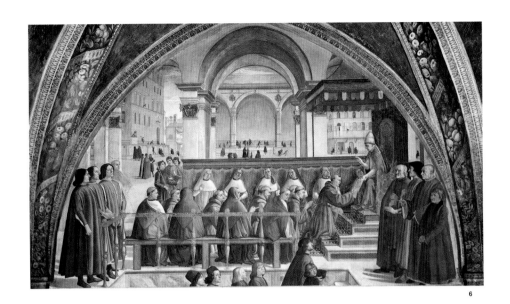

6

The early individual portrait

The beginnings of the autonomous portrait are to be found in the courtly culture of the late 14th and early 15th centuries. The Burgundian court in particular was a pioneer in this respect. One of the most remarkable cases is the portrait by Robert Campin (c.1375–1444) of Robert de Masmines (ill. p. 19), because it has been preserved in two versions of identical format. If the identification is regarded as credible, then it is the earliest autonomous portrait that can be dated with any certainty. The view that it was painted shortly before 1430 is supported by the fact that in January of that year, Robert de Masmines was made a Knight of the Order of the Golden Fleece. As knights were required to wear the insignia at all times, the portrait, in which he is not wearing it, must have been painted earlier.

A striking feature is the incredible naturalism in the depiction of the face and its details. The textural depiction of the clothing, the hair, the flesh – right down to the wrinkles and stubble – is designed for intensive close-up viewing. Painting is revealed as a means of bringing the person portrayed to life.

While in early Netherlandish portraiture the backgrounds are still monochrome foils, a void so to speak, by the mid 15th century landscape views are slowly making their entry into the paintings. We cannot always decide whether a particular region is intended. As a rule, the sitters are shown against an idealized well-tended landscape, signalling a new understanding of nature. Often there are allusions to the literary topos of the classical *locus amoenus* (the "pleasant place"), to nature visualized as the sum of landscape characteristics such as fertile arable land, green meadows, gentle hills, distant mountains, accessible forests, navigable or otherwise usable rivers and lakes, walled farmyards or affluent towns. If people appear, then they are doing something and in harmony with their surroundings.

Sandro Botticelli (1445–1510) and Hans Memling (c. 1433–1494) illustrate the new combination of portrait and landscape (ill. p. 7). The young nobleman in Botticelli's painting is holding with both hands up against his breast a medallion depicting Cosimo de' Medici the Elder (d. 1464). One may with justification conclude from this portrait within a portrait that there was a special relationship between the two, but to this day the main figure in the picture has not been identified. Important for this period is the shaping of the medallion as a gilt relief in the painting. This indicates not only the high value placed on the revived art of the classical medallion, but also the contrast between the two portrait media: the painting serves the purposes of

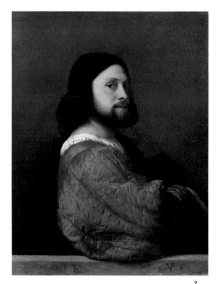 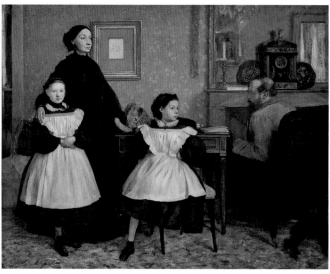

7 8

display in a public or private building, while the medallion is a portable object in the communicative act of reciprocal giving among statesmen, humanists or friends – as a memento of the absent and the dead. Memling's sitter by contrast is presenting an Antique coin with the profile of Emperor Nero, which has aroused speculations concerning its Christian moral content, since Nero, as a persecutor or Christians and destroyer of Rome, did not have a positive reputation. It is also possible, though, that all that is meant is an interest in collecting, and pride in possessing, classical antiquities.

In Venice, the individual portrait had, since Antonello da Messina (c. 1430–1479), Giovanni Bellini (c. 1427/30–1516, ill. p. 1) and Giorgione (c. 1477/78–1510), occupied a special place in the social arrangements of the republic. Titian (c. 1487/90–1576) brought this tradition to a zenith in the 16th century. His portrait of a bearded nobleman (ill. p. 12) has hitherto been interpreted as that of the poet Ariosto, although recently it has been mooted that it may be a self-portrait. There is no way of settling the issue at the moment. The parapet on which the sitter is leaning, which otherwise marks the border of the picture, derives from Venetian tradition. Titian admittedly ignores this, for the painted elbow appears to be jutting out towards the beholder. Titian is well aware of how to capture attention by the dignified man-

ner in which the face is turned to the beholder, while at the same time the sitter is arrogantly looking down on us, his trunk arrogantly turned away, the shoulders emphasized. This discrepancy between the direction of the body and the eyes, this variance of head and body, facial expression and gestures, was from then on to offer portrait painters a kind of gamut of expressive nuance between detachment and intimacy. Titian's nobleman embodies the ideals of the age, with his concentrated look articulating a serious ethos in a framework of self-assurance appropriate to his rank.

Giorgione and Titian were also the ultimate begetters of a portrait of a man in armour (ill. p. 16) by Giovanni Gerolamo Savoldo (active 1506–1548), which confronts scholars with the mystery of who might have had himself so elaborately portrayed. The old notion that the sitter was the French military commander Gaston de Foix (d. 1512) has been refuted, but we can still nonetheless assume that it *is* a portrait. Without a doubt, the picture represents a painterly contribution to what is known as the "paragon" debate, which was concerned with whether painting or sculpture was the higher art. Savoldo demonstrates the greater scope of painting to represent different views of the body at the same time. Giovanni Gerolamo Savoldo's portrait harbours a memory of a lost work by Giorgione, which, according to anecdotal tra-

7 October 1571 — Naval victory of Spanish and Venetian fleet at Lepanto ushers in decline of Turkish hegemony in Mediterranean
July 1588 — Defeat of Spanish Armada by English fleet

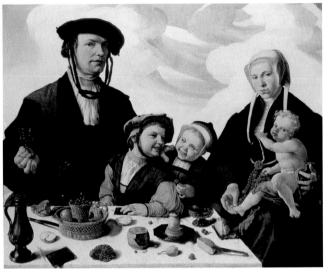

7. TITIAN
A Man with a Quilted Sleeve
(so-called Ariosto)
c. 1512, oil on canvas,
81.2 x 66.3 cm
London, The National Gallery

8. EDGAR DEGAS
The Bellelli Family
1858–1867, oil on canvas, 200 x 250 cm
Paris, Musée d'Orsay

9. MAERTEN VAN HEEMSKERCK
Pieter Jan Foppeszoon and his Family
c. 1530, oil on wood, 118.7 x 140.2 cm
Kassel, Staatliche Museen, Gemäldegalerie
Alte Meister

9

dition, used reflections in water to show different aspects of a figure. The potential of the mirror motif continued to be exploited in portraits time and again.

couples and families

In parallel with the development of the individual portrait, a custom also developed of painting joint portraits of married couples, at first in the form of individual pictures linked by the reciprocal orientation of the heads. Most of these pairs have since been separated by external circumstances. Marriages were prepared by an exchange of portraits as part of the dynastic alliance, and following the wedding, they were captured thus in pictures. Jan van Eyck's so-called *Arnolfini Wedding* represents a special case, and has remained particularly puzzling (ill. p. 31). Archetypal, by contrast, is the pair painted by Piero della Francesca (1410/20–1492) of Federico da Montefeltro and his wife (ill. p. 33).

The family as the smallest core unit in society can, through the group portrait, be embedded into a political programme, as Andrea Mantegna (1431–1509) did for the Duke of Mantua in the Camera degli sposi (bridal suite) in the Palazzo ducale, or as Ghirlandaio did for the Florentine Sassetti (ill. p. 11) and Tornabuoni in their family chapels at the end of the 15th century. In the Netherlands Maerten van Heemskerck (1498–1574) depicted family harmony more intimately (ill. p. 13). A coat-of-arms on the signet ring on the father's left hand in the middle of the picture allowed the family to be identified as that of Pieter Jan Foppeszoon. The gathering at table against the bluish-white sky translates the family to an unreal scene, whose internal logic is due to its theological symbolism. The mother on the right, with her almost naked youngest child, is an allusion to the image of the Madonna, the resemblance of the boy child to the archetypal Christ-child is too obvious to mention. The allusion to a worldly adaptation of the Holy Family can be seen too in the manner in which the man on the left raises his wine glass, which, in combination with the raisins and nuts on the table, has been interpreted as a eucharistic motif. Quite generally the laid table can also been seen as a bravura still-life, painted with a brilliance somewhere between the delicate preciosity of the early Netherlandish painters, and the heyday of Dutch still-life painting in the Baroque. The religious seriousness of the parents is relaxed by the two laughing children in the middle, who are not the least bothered by the pious intention of the arrangements. The composition of harmo-

1618–1648 — Thirty Years' War 1643–1715 — Louis XIV rules as "Sun King" in France
1683 — Turkish army lays siege to Vienna

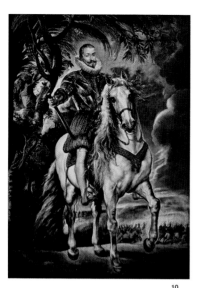

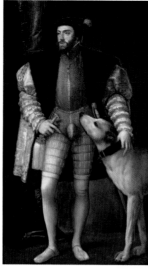

10 11

10. PETER PAUL RUBENS

The Duke of Lerma on Horseback
1603, oil on canvas, 283 x 200 cm
Madrid, Museo Nacional del Prado

11. TITIAN

Emperor Charles V with Mastiff
1532/33, oil on canvas, 194 x 111 cm
Madrid, Museo Nacional del Prado

12. ANTHONY VAN DYCK

Charles I, King of England, out Hunting
1635, oil on canvas, 266 x 207 cm
Paris, Musée National du Louvre

13. JACQUES-LOUIS DAVID

Bonaparte Crossing the Alps by the
Great St Bernard Pass
1800, oil on canvas, 272 x 232 cm
Berlin, Stiftung Preussische Schlösser
und Gärten, Schloss Charlottenburg

nious family idylls with the man as breadwinner and the woman as mother and child-rearer can be found until well into the 19th century, with the continuing allusion to the Holy Family.

In aristocratic family portraits, the dynastic claim is mostly the primary concern. With his large-scale painting *Philip Herbert, Earl of Pembroke, and his Family* (ill. p. 20) Sir Anthony van Dyck (1599–1641) succeeded in the grand manner in conveying the complexities of generational and marital relationships through the use of subtle rising and falling positions and groupings. Even the deceased children are incorporated in the guise of flying *putti*. Heraldically, the coat-of-arms on the curtain at the back make it clear which family is being staged here. In the middle of the picture is Lady Mary Villiers, who in 1635 had married the Earl's eldest son Lord Herbert, who, in red robes, stands next to her three steps higher and is looking towards his parents. This new dynastic alliance may well have been the occasion for the painting, and supports its dating. The poses follow a pictorial logic of family roles and direction of gaze with indicative gestures, but van Dyck knows well how to employ his inimitable use of colour to trump the rigid conventions of behaviour.

By the mid 19th century, such pictorial patterns had in the course of a varied development finally exhausted themselves. When Edgar Degas (1834–1917) set about working on the family portrait of his aunt Laure Bellelli (ill. p. 12), a process which took ten years, in order to reap praise at the exhibition of the Paris Salon, the result was a picture of crumbling domesticity with questionable role behaviour. Degas has the figures pose on a very tight stage in front of a wall with a fireplace, with the father unmistakably edged to one side between table and chimney. Only the mirror above the mantelpiece mitigates the impression of confinement. His role as head of the household is positively discredited, not least because Degas portrays him from behind with just a hint of a profile as he turns towards his wife and daughters. But none of them is looking at him. The group on the left form a unit in themselves, the mother stands stiffly behind the girls and gazes out aimlessly into space. Her right hand is placed maternally on the shoulder of the younger daughter, while the other, putting on a display of defiance with her hands on her hips and one leg curled up, occupies centre stage. Each person seems to exist only for him or herself, there is no hint whatever of any atmosphere of family affection. While the painting exhibits a high degree of technical perfection, the public were so confused by the disturbed communication it displayed that the result was a flop. There was probably a feeling that the bourgeois family ideology had become questionable. Even so, Degas's

1688/89 — "Glorious Revolution" in England, Bill of Rights guarantees constitutional monarchy
1689–1725 — Russia becomes great power under Peter the Great

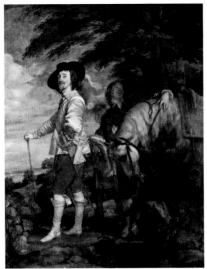
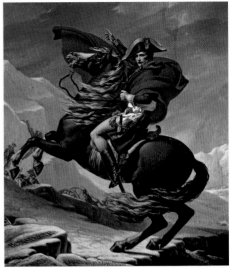

12 13

painting also makes it clear that the photography of the time was not called upon to create such *mises-en-scène.*

Group identities

Apart from family portraits, an identity shaped in a series of dynastic images, or in a particular social class or occupational group, finds its expression in the group portrait, which was among the most complex and difficult tasks of the genre and in the nature of things made demands comparable to those of the narrative painting, for a largish number of people had to be brought into some sort of well-considered mutual relationship, and united in a composition that transcended them all as individuals. This tradition began with a dedicatory miniature in a codex, which is attributed to Rogier van der Weyden (1399/1400–1464) and was painted in about 1447 for Duke Philip the Good of Burgundy (ill. p. 9).

Memoria, the commemoration of ancestors by posterity, is one of the chief motivations for group portraits. One of the most remarkable examples, in this case donor portrait and group portrait at the same time, was painted by El Greco (c. 1541–1614) in Toledo, name-ly *The Funeral of Count Orgaz* (ill. p. 10): numerous contemporaries of the artist appear in an unreal gathering as witnesses to an imagined funeral ("imagined" in the sense that it had taken place centuries before). The body of Count Orgaz is borne by a bishop and his deacon and is to be buried beneath the chapel floor in the place where, then as now, the real grave is. Any formal references to pictures of the entombment of Christ are not coincidental. In the background, members of Toledo high society are drawn up in ranks and following the proceedings, while at the same time looking up, because in the sky an angel is guiding the soul of the deceased, in the form of a small figure, through the clouds to the Virgin and John the Baptist, who are both interceding with Christ for its salvation. With numerous figures, and a complex spatial composition, El Greco is staging a vision which seeks to be understood as authentic, by dint of the group portrait of the local aristocracy, but at the same time also appeals to the beholder as a witness, as he or she can understand the apotheosis of the soul as giving permanent meaning to the chapel.

It was always the privilege of the aristocratic, clerical and business elites to stage themselves as groups. Finally in the 17th century, the bourgeois group portrait of urban elites in Holland enjoyed a grandiose heyday, and developed into an autonomous genre. The rea-

1701–1714 — War of Spanish Succession 1740–1748 — War of Austrian Succession
mid 18th century — Start of industrial revolution in Britain

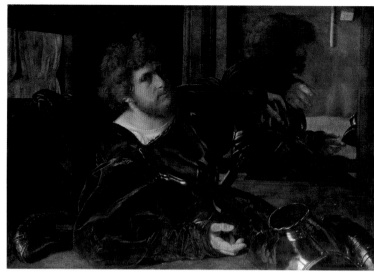

14. GIOVANNI GEROLAMO SAVOLDO
<u>Portrait of a Man (so-called Gaston de Foix)</u>
c. 1520/30, oil on canvas, 91 x 123 cm
Paris, Musée National du Louvre

15. FRANS HALS
<u>Banquet of the Officers of the St George</u>
<u>Civic Guard</u>
1616, oil on canvas, 175 x 324 cm
Haarlem, Frans Hals Museum

14

sons can be found in political change and market conditions. The increased desire on the part of the bourgeoisie for self-display expressed itself in group-portraits of corporations with an obligation to the common good. For this reason the Dutch group portrait is also known as a "corporation portrait". The essential distinction between this and Italian examples such as the Sassetti chapel in Florence lies in the pronounced co-ordination of the protagonists. Often sophisticated compositions were thought out in order to point up the group unit and at the same time bring out the subtle distinctions within it. Rembrandt (1606–1669) was a master of this (cf. ill. p. 55). By contrast, in Italy more importance was attached to subordination, so that relative status was explicitly recognizable.

Dutch group portraits took the form above all as militia pictures, guild pictures or council pictures, in other words of group-portraits of rule-governed corporations that formed an elite for a particular function. Pictures like these dominated the rooms in which they met, giving visitors a chance to identify and admire the current incumbents of the various offices. In their way, the group portraits constituted the counterparts of the portrait of the ruler in other countries. The offices of those captured in the portrait, their functions in the state or the city, were important, as was their prestige as members of the militia, direc-

tors of welfare institutions (orphanages, workhouses) or professional organizations (guilds). In Amsterdam and Haarlem, for example, the militia portrait was particularly popular.

Frans Hals (1580/85–1666) painted some of the most remarkable group portraits. He himself was a member of the Civic Guard of St George in Haarlem from 1612 to 1615, for whom he had painted a total of five large group portraits by 1639. These militias were the "home guard" of the town. In Haarlem, one year's service was obligatory, and the departing members had to lay on a banquet. The painting *Banquet of the Officers of the St George Civic Guard* by Frans Hals (ill. p. 17) shows the banquet of the officers who had served between 1612 and 1615. The red-and-white sashes represent the colours of the town of Haarlem. While at first sight it might look as if what we have here is a spontaneous comradely gathering, the twelve figures are positioned according to rank. The highest-ranking, with the yellow sash, is sitting at the head of the table on the left of the picture. Hals avoids a centred triangular composition, and uses the diagonal to emphasize the most important sitter.

If we look at 19th-century group portraits, on the other hand, we find different concepts. *Studio in Les Batignolles* (ill. p. 21), painted by Henri Fantin-Latour (1836–1904) in 1870 (in conscious reference to

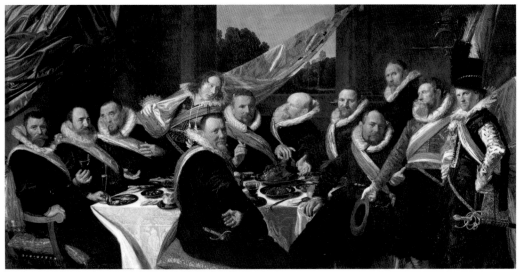

the Dutch tradition), is part of a four-painting sequence in which famous painters of the 19th century are brought together in a fictitious conversation. The scene is telling: Édouard Manet is sitting in front of the easel, painting, surrounded by artists and men of letters – a gathering that never took place. The concept takes up the old tradition of the *sacra conversazione,* a genre of religious picture in which a number of saints are portrayed standing in silence around the Madonna.

With this imaginary communication, Fantin-Latour found scorn being heaped upon him. None of those present is actually talking to his neighbour. The canvas can only be seen from behind, and it is a matter of speculation which picture is currently being painted. The same technique had already been employed by Velázquez and Goya, a cross-reference used by Fantin-Latour to show Manet as a great admirer of Velázquez.

But the picture contains more than just a superficial artist-cult. It reveals a new type of homage picture, resulting from a combination of old group-portrait and new group-photo. The composition principles of painting continue to function, and in the process help to cover over the disturbances in communication, but at the same time we see an attempt to achieve the casualness of a group-photograph. But photographs at this time were invariably posed, and thus anything but casu

al. The higher goal is nevertheless clear: Fantin-Latour aims to link the ideal nature of a group of friends like this with his painterly realism, so that an allegedly everyday studio scene is elevated to the status of an allegory, and what is allegorized is a new understanding of art. The naturalistic portraits of the people are once more to be seen in the function of witnesses to a fictitious event.

Portraits of power

In Venice the office of Doge gave rise to a specific portrait form, which attained "approved" status with Giovanni Bellini's portrayal of Doge Leonardo Loredan (ill. p. 1). As a "state portrait" it unites the achievements of the early individual portraits with the aura of the head of state. To this extent, Bellini was bound to retain the ceremonial garb with the horn-shaped cap along with an appropriate official expression. It is no coincidence that the painted bust behind the balustrade is reminiscent of sculptured busts, which the Italian Renaissance produced in great number. The commission doubtless required an immobile expression, but Bellini nevertheless succeeded in using delicate brushwork and subtle lighting effects to suggest a higher unity of per

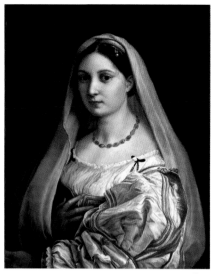

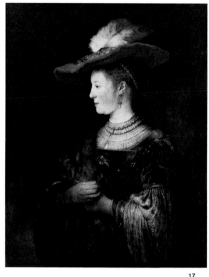

16 17

son and office. In comparable fashion, the later papal portraitists were confronted with this task for each new incumbent.

In the course of the 16th century various types were laid down for portraits of rulers and aristocrats, the intention being always to express rank and status through formats and appropriate cropping. The life-size full-figure portrait, for example, only developed gradually in the service of display. It signalled the highest rank, or a corresponding self-confidence, and was reserved for rulers and the holders of the highest offices. Social differentiation was then marked by gradations from the knee-length via the half-length figure and bust to the head-and-shoulders portrait. A convention quickly developed whereby it was considered inappropriate to commission a portrait above one's station: those who ignored it risked being censured for pretension or arrogance.

It took some while for the life-size full-figure ruler portrait to achieve autonomous status, although early preliminary stages are to be found in altar-pieces. An important example is Albrecht Dürer's (1471–1528) Paumgartner Altar (today in Munich, Alte Pinakothek), on which two martial saints are depicted on the inner wing panels; these have certain portrait-like features, and so it is possible that they are in fact concealed portraits. Only with the two lifesize portraits of the Elector of Saxony and his wife painted in 1514 by Lucas Cranach

the Elder (1472–1553) (today in Dresden, Gemäldegalerie Alte Meister), did this new type of picture emerge in the temporal sphere from the couple portrait. We might ask whether in Italy Moretto da Brescia (c. 1498–1554) had any knowledge of the German beginnings of the lifesize portrait, for certainly his portrait of an unknown nobleman in London (National Gallery) is dated remarkably early at 1526.

It was Titian, who was largely responsible for the breakthrough of this kind of state portrait. In recent years, the portrait of Charles V (ill. p. 14) has given rise to a discussion of its authorship, a debate settled in favour of Titian by technical examination. Charles V is standing in a relaxed contrapposto pose, his head half turned to the left, wearing not imperial garments, but rather costly aristocratic gear. He is identifiable beyond doubt, but Titian has regularized his features: the emperor is known to have had a strikingly hooked nose and the famous projecting Habsburg jaw. An even more important portrait of Charles by Titian shows the emperor on horseback following the Battle of Mühlberg on 24 April 1547, at which he defeated the protestants. With this painting, which was likewise begun in Augsburg, Titian establishes the lifesize equestrian portrait as a particular version of the state portrait. It depicts Charles not as a general in the battle, but as the emperor triumphant, riding forwards dynamically in ceremonial ar-

1830 — July Revolution in France
1853–1856 — Crimean War

1848 — March Revolution: failed attempt to form German national state
1861–1865 — American Civil War

16. RAPHAEL

Portrait of a Woman (La Velata)
1516, oil on wood, 85 x 64 cm
Florence, Galleria Palatina, Palazzo Pitti

17. REMBRANDT HARMENSZ. VAN RIJN

Portrait of Saskia van Uylenburgh
1633/34, oil on wood, 99.5 x 78.8 cm
Kassel, Staatliche Kunstsammlungen,
Gemäldegalerie Alte Meister

**18. ROBERT CAMPIN
(MASTER OF FLÉMALLE)**

Robert de Masmines
c. 1425, oil on wood, 28.5 x 17.7 cm
Berlin, Staatliche Museen zu Berlin – Stiftung
Preussischer Kulturbesitz, Gemäldegalerie

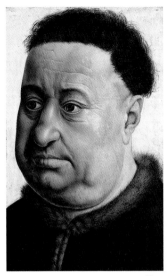

18

mour. Behind the equestrian motif is a clear allusion to the classical story of Alexander the Great and his mount Bucephalus, recounted as exemplifying the virtues of leadership. Philip of Macedon, the story goes, had been offered the magnificent white horse Bucephalus, but the steed was so wild that no one could ride it. No one knew what to do, the horse seemed untamable. Alexander however noticed that the beast only got nervous when it could see its own shadow moving in front of it. So he faced it into the sun, spoke soothing words, mounted, and tamed it. No other was ever able to ride it. According to Plutarch, Alexander's father said: "Seek an empire that is worthy of you. Macedonia is too small." The taming of the wild horse is a metaphor for the talent of taming a state, and running its government on a tight rein. This kind of comparison was easy to understand, and also to demonstrate, either in an equestrian painting, or, better still, with an equestrian statue.

The repertoire of the state portrait in the 17th century would be inconceivable without the equestrian picture, and, with Titian's painting as model, it is not surprising that this type found a particular echo at the Spanish court. Peter Paul Rubens (1577–1640) learnt this lesson very quickly, when in 1603 he was commissioned to paint an equestrian portrait of the powerful Duke of Lerma (ill. p. 14), whose position at court allowed him to have himself painted thus. Rubens has the duke ride towards the beholder, while in the background the serried ranks of cavalry charge forward in battle. The duke is sitting calmly in the saddle, his staff of command resting on his thigh. Unlike Titian's Charles V, Rubens presents the rider bare-headed in victorious pose on the prancing steed. Cleverly he uses a tree to frame the horseman.

The equestrian portrait could appear in countless variations in the 17th and 18th centuries, for under the *ancien régime* it was the noblest task of any court painter. Sir Anthony van Dyck chose a version of his own for his portrait *Charles I, King of England, out Hunting* (ill. p. 15). Here the king is not depicted monumentally on horseback, but is resting from the chase, standing next to his horse looking out over the sea, while his mount is held by a groom. Charles is elegantly posed, adopting the stance of a courtly dancing-master, his right arm extended and resting on his cane, while his left hand, holding his gloves, is on his hip. The body is seen from the side, the nearer elbow having the brightest highlight, while the king casts his casually sovereign gaze towards the beholder.

One might think that the French Revolution and the overthrow of aristocratic equestrian statues, especially in Paris, would have put an end to this type of portrait commission, but it was no less a figure

1870/71 — Franco-Prussian War, foundation of German Empire
1914–1918 — First World War

1911/12 — Chinese Revolution
1917 — Russian Revolution

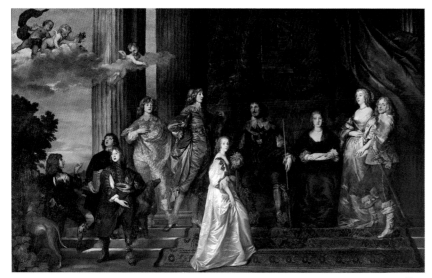

than Napoleon who lent this form a new character. In this respect Jacques-Louis David (1748–1825) was the ideal painter to translate Napoleon's idea into the formula of a propaganda picture. David's painting *Bonaparte Crossing the Alps by the Great St Bernard Pass* (ill. p. 15) is the grandiose culmination of the story of the equestrian portrait, and at the same time also the swansong of this motif. The pathos here could not be surpassed. After Napoleon's victorious Italian campaign David started work on two versions of the painting in 1800, which were followed by further copies.

Napoleon seems to be riding up a steep slope from the right; however the horse is rearing up on its hind legs in such a way as to dramatically exaggerate the upward movement. Likewise, the strong tailwind suggests stormy progress in the mountains, the uncompromising will to tame the Great St Bernard. Napoleon, though, is sitting calmly in the saddle, and seemingly effortlessly he controls the rearing horse with his left hand, without however drawing the reins tight. The flowing cloak is designed to lend Napoleon's figure awe-inspiring volume. When we consider how small Napoleon actually was, we can see how David has manipulated the dimensions of horse and rider in the general's favour. Fearfully large, the eye of the horse looks the beholder in the face, a touch designed to trigger a subliminal but effective

emotion in the latter. Napoleon too is looking towards the beholder, and with his outstretched right arm is pointing in the direction in which the campaign of conquest will lead. The feat of leading an army over the Alps is underlined by the names carved in the rock: Hannibal and Karolus Magnus (Charlemagne) can be read, and, heading the list, Bonaparte. Thereby Napoleon demonstrates his historical lineage.

The staging and masking of feminine beauty

Portraits of women form a category of their own, because here beauty, as a pictorial variant of praise of the fair sex, was never a topic that could be easily ignored. The notion of beauty pursued various different ideals over the centuries. In the 14th, Petrarch had raised the praise of women to a high art with his sonnets to Laura, establishing the adulation of beauty as a literary motif. Women's portraits of the Renaissance often betray their indebtedness. At first it was the profile portrait that was standard for women. In early examples, the profile often comes across as a two-dimensional stencil, but with the striking line of forehead, nose, mouth, chin and throat, we have a decidedly individual character profile. Hairstyle, hair decoration, and clothing distin-

1919 — Versailles Conference, foundation of League of Nations 28 October 1922 — "March on Rome" ushers in Fascist regime in Italy
25 October 1929 — "Black Friday" ushers in great depression

> "The painter, the true painter, will be the one who knows how to see the epic side of our present-day life, who… lets us see and understand how great we are, and how poetic in our cravats and polished boots."
>
> Charles Baudelaire, 1845

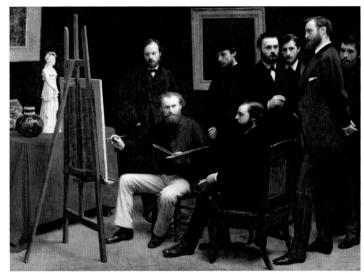

20

guish the sitters as high-ranking persons, and the costliness of all the materials was designed to be carried over to the wearer (see for example Ghirlandaio's *Giovanna Tornabuoni,* ill. p. 35).

Leonardo da Vinci (1452–1519) in particular had given some thought to the representation of beauty, and the praise that was later accorded his portrait of the *Mona Lisa* (ill. p. 39) is evidence of a continuing convention in taste in respect of female portraits of this kind. Raphael (1483–1520) had as a young man learned a lot from Leonardo, not least from his *Mona Lisa,* whose type he studied and further developed. The anonymous portrait of a young woman, who by reason of her veil is known as *La Velata* (ill. p. 18), raised many questions in this regard. Raphael painted this portrait with great attention to detail, which suggests a personal relationship with the sitter. The veil – as with the *Mona Lisa* – points to a married woman. A wedding may also have been the proximate cause for the splendour and exclusivity of Raphael's *La Velata* too. We have a half-length portrait of a lady in a costly gown whose fabric flows around her body. The veil over her head gives her a closed outline and frames her face, whose beauty results from the even, symmetrical features. With her right hand she is grasping for her heart, a gesture designed to underscore her grace. In the ideal of the time, a beautiful soul guaranteed a soulful beauty.

Rembrandt also used clothing and jewellery in brilliant fashion when he started the *Portrait of Saskia van Uylenburgh* (ill. p. 18) in 1633/34, maybe on the occasion of her betrothal on 25 June 1633 (they were married in 1634). Rembrandt worked on the painting until after Saskia's death in 1642, and probably added the jewellery and feather last of all, something that has been interpreted as an allusion to transience. The portrait, now in Kassel, relates however to the early days, for we see a young woman whose beauty Rembrandt doubtless understood as "radiant", in that he illuminated her face to great effect. Rembrandt's lighting makes Saskia shine out from the dark background, and fills all the costly materials with reflections and lush colours. The clothes are striking, because Rembrandt chose an historical costume from the Renaissance. X-ray analysis shows that Saskia was originally holding a dagger, and was being depicted in the role of the classical princess Lucretia. Such a case is known as a crypto-portrait, which can be mythologized, allegorized or historicized. These costume-portraits are very common from the 16th to the 18th century, and Rembrandt's intention may have been to cast his young wife as the princess in order to stage historical beauty. All his painterly endeavours were engaged for this profile portrait, whose concentrated expression can be explained by Lucretia's thoughts of suicide. Even if we

30 January 1933 — Adolf Hitler appointed chancellor in Germany
1936–1939 — Spanish Civil War, victory of fascist Franco regime

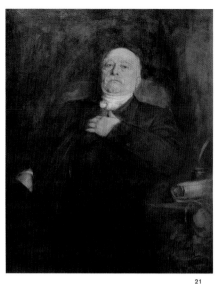

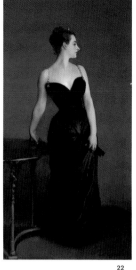

21

22

21. FRANZ VON LENBACH

<u>Former Chancellor Otto von Bismarck</u>
1896, oil on canvas, 120.5 x 100.5 cm
Dortmund, Museum für Kunst und
Kulturgeschichte

22. JOHN SINGER SARGENT

<u>Madame X (Virginie Avegno Gautreau)</u>
1884, oil on canvas, 208.6 x 109.9 cm
New York, The Metropolitan Museum of Art,
Arthur Hoppock Hearn Fund

23. PABLO PICASSO

<u>Portrait of Daniel-Henry Kahnweiler</u>
1910, oil on canvas, 101.1 x 73.3 cm
Chicago, The Art Institute of Chicago,
Gift of Mrs. Gilbert W. Chapman in
memory of Charles B. Goodspeed

didn't know who the lady was, we'd realize immediately that the painter had created a particularly intense and personal portrait.

With the early modern period, the problem field of beauty, idealization, character and "essence" came to a head during the 19th century, a process manifested in the staging of women in marginal situations. The role patterns had gradually shifted in the context of bourgeois ideals. The *fin de siècle* paid homage to glamorous beauties, or favoured such stereotypes as the *femme fatale* or *femme fragile.* Society painters did particularly well by painting portraits. John Singer Sargent (1856–1925) pulled off a spectacular debut with his *Madame X* (ill. p. 22) at the 1884 Paris Salon: a masterpiece with a hint of scandal. As usual, the sitters for women's portraits remained anonymous when the paintings were exhibited, but everyone knew that portrayed here was one of the most beautiful and glamorous ladies in Paris, Virginie Avegno Gautreau, an American married to a French banker. Sargent painted her standing by a table on which she is affectedly supporting herself with her right hand, while with her left hand she is gathering the fabric of her dress. In the black of the dress, Sargent rivals Manet. The bodice of the dress and the narrow pearl-studded straps emphasize the daring décolleté and its noble pallor. The little crescent in her hair is intended to characterize her as Diana,

the moon goddess, the goddess of the night, at home in the artificially lit salons of Parisian high society. Her demonstrative unapproachability immediately inspired evil tongues to mock this "new Nefertiti". Mme Gautreau blamed the painter, whereupon he turned his back on Paris. But the scandal helped him to become a fêted salon painter in the English-speaking world.

An echo of the *femme fatale* from the world of pleasure was painted by Otto Dix (1891–1969) in the *Portrait of the Dancer Anita Berber* (ill. p. 24), who after the First World War performed scandalous dances in the cities of Europe, and cultivated a lifestyle devoid of taboos. In this portrait, Dix unites in unique fashion *joie de vivre* and transience in the mask of the make-up and the enticing red of the dress: the woman comes across as both beautiful and raddled. What we have here is clothed nudity with flowing folds, a piquant turning movement and a provocative colour orgy of different shades of red, all of which send out erotic signals but place her on the edge of the abyss. Colour in the work of Dix became libido incarnate in the sense of Sigmund Freud, symbolizing primal urge and decay in the tension between *eros* and *thanatos,* desire and death.

1939–1945 — Second World War
6 and 9 August 1945 — America drops nuclear bombs on Hiroshima and Nagasaki

"Drawing day and night, he animates the abstract and consolidates the tangible."

André Salmon on Pablo Picasso, 1920

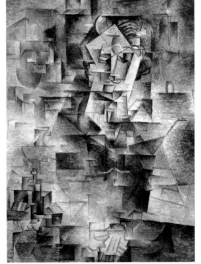

23

Transformations and polyperspective characters

In turn-of-the-century Vienna, Gustav Klimt (1862–1918) reformulated the modern feminine portrait. With a visually confusing pictorial concept, characterized by ornament, he succeeded in using form and colour to transform the conventional high-society female portrait into an aesthetic decorporealization. His portrait of *Adele Bloch-Bauer I* (ill. p. 24) is one of the major works of a period when gold determined the chromatic expression. The total two-dimensionality is dominant; only the flesh tones are gently moulded, but even they come across as pasted-on cut-outs. The head seems to be hovering in the restless small-scale decorations. The background and foreground are one. Adele's figure is fitted into a stylized armchair with high back and sides, sitting and standing at the same time, and the dress with its horizontal eye-of-God motifs is surrounded by a flowing ornamentalized wrap. Gold is for Klimt the means of depicting spacelessness, recalling the temporally distant gold grounds of icons and early-Christian mosaics, referring thus at the same time to material substance and immaterial light, shifting the portrait into timelessness. Klimt had revoked the centuries-old laws of the illusionist picture and banished the portrait character to the abstracted two-dimensional pattern of the ornament.

Gustav Klimt's young admirer and fellow Viennese artist Egon Schiele (1890–1918) interpreted the relationship of tension between figure, surface and space with a radical exposure of the emotional. His portraits, which represented both his livelihood and a field of experimentation, are permeated by the search for authentic expression, an addiction to psychological and bodily nakedness, which cannot deny theatrical *mises-en-scène* and nevertheless offers up a hitherto unknown revelation of the individual. In 1912 the publicist Arthur Roessler wrote that Schiele had the ability to "turn human beings inside out". The most radical examples of his turning humans inside out was performed in the self-portraits, in more moderate fashion in the commissioned works such as the portrait of the publisher Eduard Kosmack (ill. p. 4). Just as Schiele subjected his models to his own dissecting gaze, he also tried to catch the intensity of Kosmack's gaze, to which hypnotic qualities were attributed. The slim, black-clad figure of the publisher, its body-language betraying nothing, seems to be some kind of prepared sample against the whites of the background. On longer inspection, his eyes turn out to be concentration-points of posture and colour-expression. It seems as though Schiele wanted the portrait to return the beholder's gaze and exercise its hypnotic power in the process.

24 October 1945 — Foundation of United Nations **1950–1953 — Korean War**
25 March 1957 — Treaty of Rome creates European Economic Community

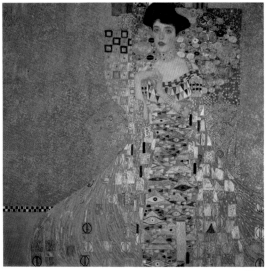

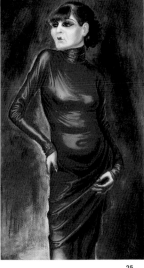

24

25

Another path, which was considered to be more radical in the way it disposed of traditional habits associated with the action of seeing, was taken at this time by Pablo Picasso (1881– 1973) in the form of "analytical Cubism". Picasso saw new opportunities for the painter not in ornament, but in the fragmentation of the figural out of colour into Cubist forms. Even in the portrait, Picasso managed to brake up, step by step, the basic shapes and the linear structure of the portrait's face by means of dissolving the three-dimensional volumes into polyperspective facets in a colour-space structure on the surface of the picture. In this portrait of his art-dealer Daniel-Henry Kahnweiler (ill. p. 23), which was painted in 1910, the indications that it is actually a portrait are just about recognizable, but the degree to which the forms are disintegrated has been taken to its limits. The figural is reduced to signs, and translated into a number of content-less colour structures, without abandoning figural significance. In the portrait, and in head studies generally, Picasso was experimenting for nearly all his life with the possibilities of polyperspective in order to express characters.

Likeness and photography

In modern art, portrait painting was not displaced by photography, but challenged to come up with an artistic response. Since the 19th century, portrait photography had continued for a long time to fall back on the tried-and-tested pattern of social distinction. Roles and relationships are part of a mentality which sought to give the appearance of objectivity in photography, but which in truth only presented the interplay of private and public, of fashion *diktat* and individualism, in a new medium.

The society painter from Munich, Franz von Lenbach (1836–1904), who portrayed the great and the good from all over Europe, used photography very effectively as an aid, model or *aide-mémoire*. A group of works of central importance are the portraits he painted of the German Chancellor Otto von Bismarck. Lenbach worked from photographs, but varied the poses with studio props. On the portrait dated 1896 (ill. p. 22), a variant of the first version of the previous year (Munich, Städtische Galerie im Lenbachhaus), is also based on a recent photograph, and shows the aging Bismarck, five years after his dismissal from office and three years before his death, sitting in an armchair, his voluminous form commanding respect. His face is

1966–1969 — "Cultural Revolution" in China under Mao Zedong 1964–1975 — Vietnam War
20 July 1969 — Neil Armstrong becomes first man to step on Moon

> "no individual can be objectively repro-
> duced by creative representation, but the
> representation can be of such a kind as
> to allow the interpreted individuality to
> be experienced by everyone, experienced
> so vehemently and directly that the indivi-
> dual person is immediately present. every
> work that achieves this is a portrait."
>
> Hermann Deckert, 1929

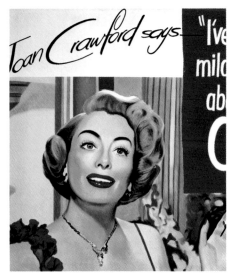

26

marked by deep concentration. Using the overt pathos of this corpore-al presence, Lenbach sought to convey the unbroken will and spirit of this *realpolitiker.*

A century later, the interactions of painting and photography are immeasurably more complex. Photographers such as August Sander (1876–1964) provided the role played out by human beings between individual existence, their milieu and their social context with new con-tours of authenticity.

In the second half of the 20th century, the question of the indi-vidual behind the surface of the picture lost more and more of its aesthetic leading function. Pop Art unmasked the stereotypes of por-trait photography, but at the same time used it to translate the subject into a new personal image of modern idolization (ill. p. 25; cf. also Andy Warhol, *Marilyn,* ill. p. 89). In the painting of the school known as Pho-torealism (cf. Chuck Close, *Richard,* ill. p. 93), the demand for imitation is redefined, through the use of hybrid techniques, as artistic super-reality. Photographers such as Thomas Ruff (b. 1958) react to the flood of images in the print media with a new portrait aesthetic, pre-senting the sitter without any sign of emotion. Facial expression or eye-language, and all the random aspects we associate with individu-ality, are avoided. Above all in large format and in serial form, what we have is a registration of the face in pictorial objectivity or sobriety. In the ambivalence between banal ID photography and the objectifica-tion of the individual, the documentary aspect is completely absorbed into the perfection of picture-creation. The question of the personality is not resolved as a result – it never will be. Even given the technical achievements of media virtualization, reflexions on the portrait as a work of art are not rendered redundant even in the brave new world of pixels.

9 November 1989 — Fall of Berlin Wall 1991 — Dissolution of Soviet Union
1 November 1993 — Maastricht Treaty creates European Union

st Louis of Toulouse

Tempera on wood, 250 x 188 cm
Naples, Museo e Gallerie Nazionali di Capodimonte

This altarpiece depicts a saint and a king, but the painter too has self-confidently immortalized himself: SYMON DE SENIS ME PINXIT can be read in the predella in evenly spaced letters next to the coats-of-arms: "Simone of Siena painted me". Simone Martini knew that he had created a special work. His fame as a leading young painter in Siena had run ahead of him, for he was a master of elegant figures and the depiction of precious materials. Above all for a donor with novel portrait ambitions, he seemed eminently suited. To present oneself as a living donor with a recognizable portrait on an altarpiece in such a prominent fashion was new, and required both an important occasion and a high rank of the portrayed person. Both were present.

Louis of Anjou was born in 1274, the second son of Charles II of Anjou, king of Naples, and was the designated heir to the throne. However, he felt called to a spiritual life, and renounced his claim to the throne in 1296. Now his younger brother Robert became heir apparent, Louis was appointed bishop of Toulouse by Pope Boniface VIII, but at the same time asked for permission to enter the Franciscan order. However, as early as 1297 he died on his way to Rome. The attempts to have him canonized were beset with complications, and the process lasted through three pontificates, although numerous miracles had already been ascribed to him. It was not until 7 April 1317 that he was eventually canonized by Pope John XXII, who was close to Robert of Anjou.

Robert, who had become king of Naples in 1309, donated the altar retable probably to the church of Santa Chiara in Naples. The large retable is framed with the heraldic lilies of Anjou. In the predella, set in an arcade, there are five small pictures with scenes from the saint's life. They show: 1. his acceptance of the episcopal office, on condition that he would at the same time be permitted to enter the Franciscan order; 2. his entry into the Franciscan order and consecration as bishop; 3. washing the hands of the poor and inviting them to his table; 4. Louis on his bier; 5. the miracle of the boy raised from the dead.

In accordance with his importance, St Louis of Toulouse is depicted seated in majesty with the appurtenances of a bishop (mitre, crozier, cope and glove), while wearing the Franciscan habit, on a backless chair, crowning his younger brother Robert. Louis himself is being crowned by two hovering angels, so that we are present at a dual occurrence: the saint is being crowned by divine decree, the king by the hand of the saint. In this way it is made clear that the divine will is transmitted to Robert too. It is a symbolic act of installation in office which seeks God-given legitimacy through the now canonized brother.

Louis is also due a frontal depiction, seated in majesty, his features rigid and schematic. Monumentally, Simone transfers the Sienese *Maestà* type, the Mother of God in Majesty, to a portrait of a saint, which, as a donor portrait, also serves to promote the veneration and prestige of the family. King Robert is depicted in the typical donor attitude, on his knees with his hands joined in prayer, looking upwards. Louis is stereotyped, there is no hint of an authentic portrait. The profile portrait of Robert, though, is different; reliable comparisons can be drawn upon. The profile owes much to classical coin portraits. While Louis the saint comes across as idealized, Robert attaches importance to his unmistakable likeness as king.

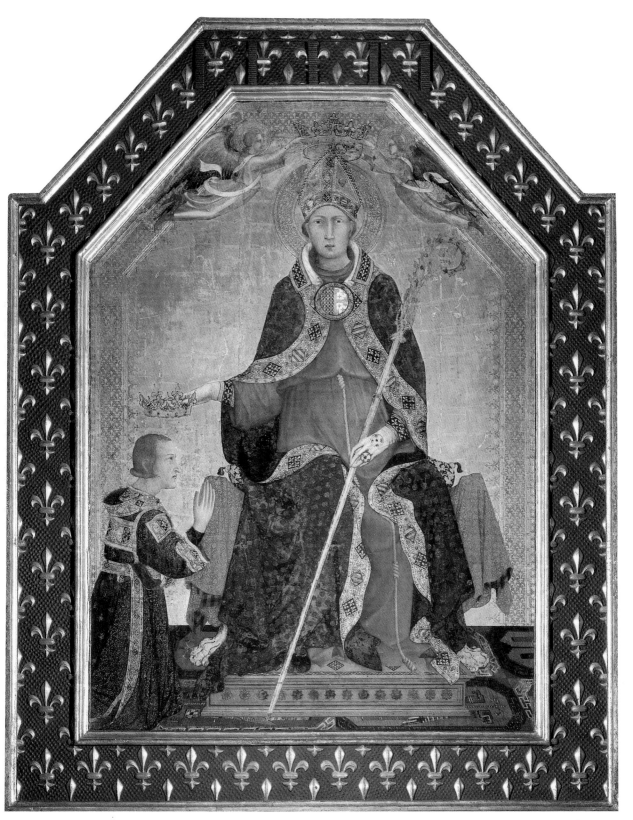

Jean II le Bon (John the Good), king of France

Mixed media on wood, 60 x 44 cm
Paris, Musée National du Louvre

This important portrait of Jean le Bon (John the Good) in the Louvre stands at the beginning of the story of the autonomous portrait in painting. The sitter is not there as a donor or bystander in some devotional picture, but seems to have been painted for his own sake, although as we do not know what function the painting served, a wider context with a donor interest cannot be excluded.

The inscription "Jehan Roy de France" is not contemporary, leading to doubts about whether the king really was the sitter. Charles V of Valois has been put forward as an alternative. But comparisons of the few paintings and sculptures depicting the latter provide no obvious reason for departing from the traditional view.

Even without the inscription, there can be no doubt that the sitter is a ruler. Jean le Bon is depicted as a profile bust, looking to the

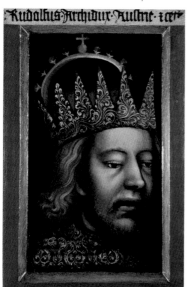

Anonymous (Prague School of painters), Portrait of Duke Rudolf IV of Austria, c. 1360

right. The feudal portrait form in the courtly context owed much to the Antique coin portrait on which the Caesars were shown in profile. The fashionable 14th-century hairstyle with the long wavy locks and the neatly trimmed courtly beard also point to a ruler. A full head of long hair served to compare its wearer to a lion, and by ancient analogy the beasts attributes were transferred to men of rank, ideally of course to rulers. The garment is a cloak with an ermine collar, such as we find in other depictions of rulers. As no crown is shown, a

narrower dating of 1349–1350 has been suggested, when Jean le Bon was still Duke of Normandy. Artistically, the painting may have been exemplary in the context of the papal court in Avignon, when one considers that among those working there shortly before was Simone Martini, who provided significant impulses for portraits. The punch marks in the painting in the Louvre would suggest this, albeit not with total certainty.

A further altogether singular work is represented by the portrait of Duke Rudolf IV of Austria, the context of which is clearer. It has a direct spatial association with his tomb in St Stephen's cathedral in Vienna, and can be classified as a memorial picture, which quite possibly was contemporary with that of John the Good. Whether the picture was painted during his lifetime *(ad vivum)* is not certain. At least we must assume that physiognomic likeness was an artistic goal here, in other words that the association was unmistakable enough even if it were painted *post mortem* in commemoration of the deceased. The combination of funerary picture and painted portrait related to the medieval doctrine of the two bodies. A distinction was made between the individual mortal body and the supra-individual official body, which lived on. In the present combination this would mean that the funerary portrait related to the mortal body, the painted portrait to the official body. This is how the ducal coronet has been interpreted, pointing to the dynastic continuity of this dignity. What is also remarkable is the three-quarter frontal aspect, which allows more of a view than does the profile of Jean le Bon, and is a sign of emancipation from classical models. This sort of portrait comes across as more complete, it was designed to convey more vitality, in contrast to the funerary image.

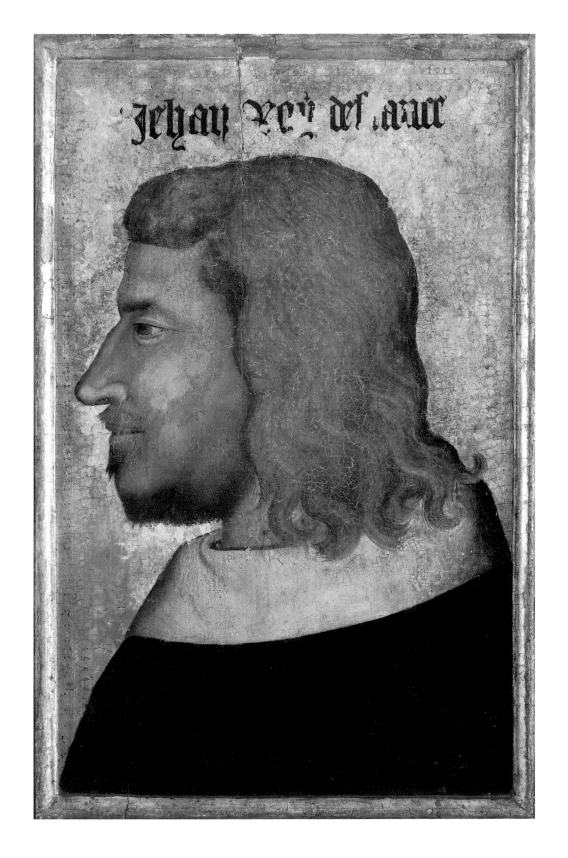

Giovanni Arnolfini and his wife (so-called Arnolfini wedding)

Oil on oak, 82.2 x 60 cm
London, The National Gallery

b. circa 1390 in Maaseyck
(near Maastricht)
d. 1441 in Bruges

The identification of the sitters as Giovanni Arnolfini and his wife Giovanna Cenami is due to force of habit. The obstinate persistence of the name Arnolfini goes back to an entry in the 16th-century inventory of the artistic collection of Margaret of Austria, in which the picture is listed as being of "Hernoulle Fin" or "Arnoult Fin". The latest research suggests that there is no such association. The problem of identification is linked to an individual portrait of the same man by van Eyck, now in Berlin, and dated c. 1438.

The 1434 painting is also known as the "Arnolfini Wedding". Two right hands joined, i.e. *dextrarum iunctio,* would represent a promise of marriage or the sealing of the marriage vows. At the same time, the man's other gesture could be interpreted as a hand raised in oath. The lack of clarity of the gestures has inflamed judgements to this day: the fact that her right hand rests in his left (!) has given rise to speculation that it may be a second wife, because then one could speak of a morganatic marriage, also known as a left-handed marriage for precisely this reason. Such marriages were contracted for example as second marriages between partners of unequal rank. A morganatic marriage conferred inferior privileges. No such marriage can be attested for any member of the Arnolfini family. Furthermore Giovanni Arnolfini and Giovanna Cenami did not marry until 1447, which cannot be squared with the date of the inscription, namely 1434. Giovanni's brother Michele Arnolfini can also be excluded, and there are no sources regarding any other Arnolfini.

The couple are depicted in the then usual multi-purpose room, serving both as living-room and bedroom. The man is standing in a fur-trimmed cape and broad-brimmed hat, turned towards the beholder, and is holding up his right hand in a gesture that could be interprete either as greeting or blessing. Neither he nor the woman is looking either at the beholder or at the other. The room encloses the couple with a domesticity in which everything appears to match reality, but could also have a symbolic meaning. However doubts have been cast on the existence of a hidden symbolism, which would underscore the marriage theme with Christian aspects.

What does seem clear, in spite of all the controversy, is that van Eyck is depicting an authentic moment: on the rear wall is written "Johannes de Eyck fuit hic/1434" ("Jan van Eyck was here/1434") and in the round convex mirror we can see two figures present in the room as witnesses. This has given rise to further interpretations: the picture has the character of a document, a legal act is being certified and in addition the inscription, it is said, implies that the painter himself was one of the witnesses. Ultimately all this is speculation. If we assume that what we have here is a picture neither of a wedding nor of any other officially known ceremony, and that the picture does not represent a legal document, we may perhaps consider a private occasion for it, which enriched the inner bonds of a couple with the representation of social rank and domestic affluence.

It has recently transpired that the picture formerly had a frame with an inscription from Ovid's *Ars amatoria* (I, 443–444): "Just promise a great deal, for what do promises cost? Anyone at all can be rich in promises." As a private portrait the picture illustrates a promise, but it promises no decipherment. Even so: it is the first full-length double portrait and one of the most important interior pictures of the early modern period.

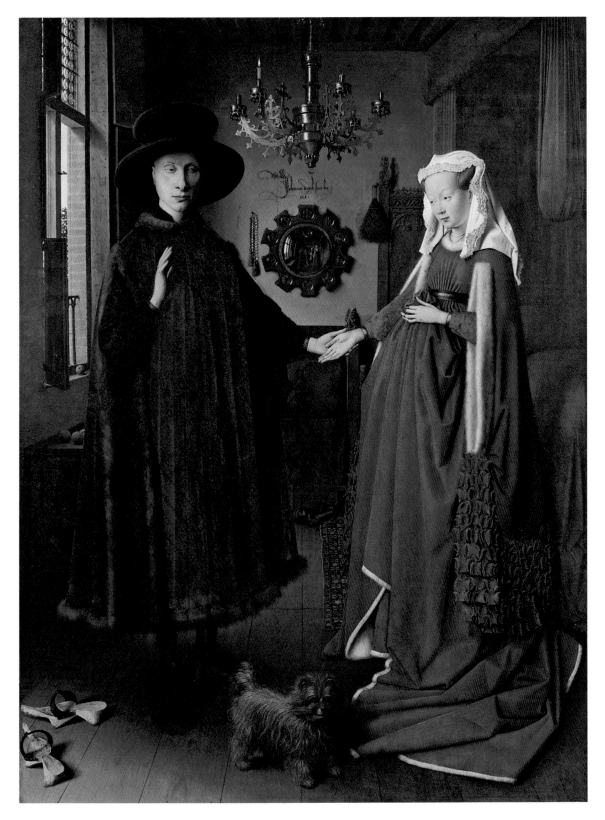

Portraits of Federico da Montefeltro and Battista Sforza

Tempera on wood, 47 x 33 cm each
Florence, Galleria degli Uffizi

b. 1410/20 Borgo in San Sepolcro
(near Arezzo)
d. 1492 in Borgo San Sepolcro

In the mid 15th century, Piero della Francesca was one of the most innovative painters, and he even wrote a treatise on perspective. His influence extended mainly to Umbria, the Marche and Tuscany. Based in Borgo San Sepolcro, where he also held public office, he executed numerous commissions in the service of princes and monasteries. One of these clients was Federico da Montefeltro, who commissioned, among other works, a double portrait of himself and his consort, a pictorial demonstration of his status. Montefeltro was one of those successful upstarts, as unscrupulous as they were cunning, who as mercenary leaders exploited every opportunity to obtain power and ruthlessly hold on to it. The double portrait is a diptych, a combination of two hinged panels.

The two spouses are depicted in profile, facing each other. The gaze of both is indeterminate, almost lifeless. However it was not only the technicalities of the diptych configuration which suggested the profile form, but rather a particular desire on the part of the client. The duke had lost his right eye in a tournament. Not wishing to lose any combat advantage as a result, he had part of the bridge of his nose removed, in order to extend the field of vision of the remaining eye. One can see from the painting that Piero attached great importance to the altered profile of his nose, and to that extent the profile has a high recognition value. The duke wears simple garments, with a red hat and red jacket, while his wife Battista Sforza appears in a rich array of pearls and other jewellery, along with expensive clothes, making clear her high rank.

The reverses of the portraits also speak volumes: depicted in each case is a triumphal chariot, drawn by white horses in his case, and unicorns in hers. The allocation speaks for itself. The chariots bear the personifications of virtues. In Federico's case these are the cardinal virtues of justice, wisdom, courage and moderation. His wife is accompanied by the theological virtues: faith, hope and love, and additionally by *pudicitia,* namely chastity or modesty. The chariots are driven by cupids as the servants of marital love. They are then the triumphal chariots of the masculine virtues of fame, and of the feminine virtues. Such *trionfi* should be seen in the context of Petrarch's poetry: his triumph verses, written in 1352, were first printed in Venice in 1470. We might therefore with some justification assume that the portraits were inspired by these verses, and painted after their publication. A more exacted dating is suggested by Federico's sceptre, for he was raised to the dukedom in 1474. A connexion can be presumed (unless it is intended to represent the staff of the *condottiere* in general terms). In this case, however, the portrait of his wife would be posthumous, for she died in 1472.

What distinguishes both pictures is the combination of the portraits with the panoramic landscape. Piero uses the latter to indicate that the two panels form a unit, by having a common horizon and a common prospect both *recto* and *verso*. Much thought has been given to whether this landscape is real, namely somewhere in Federico's territories in Umbria, but it is more likely that what we have is a mixture of typical landscape features and idealized juxtapositions of the sort of cultivated landscape to be expected in a well-governed region.

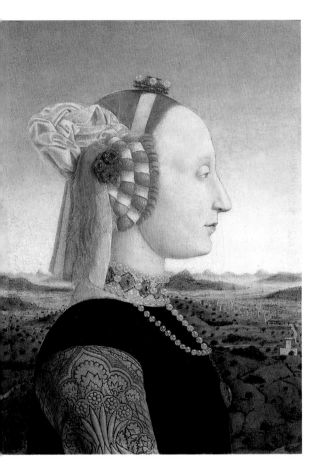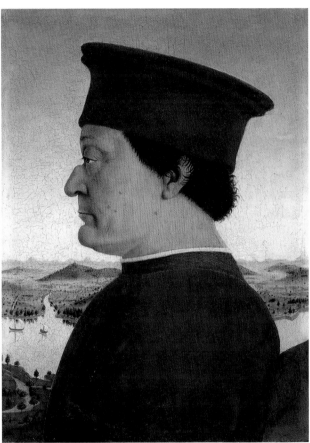

Portrait of Giovanna Tornabuoni

Tempera and oil on wood, 77 x 49 cm

Madrid, Museo Thyssen-Bornemisza, Fundación Colección Thyssen-Bornemisza

b. 1449 in Florence
d. 1494 in Florence

Domenico Ghirlandaio, who as a painter was Michelangelo's teacher, ran the leading studio in Fliorence in the late 15th century. Among his famous achievements are the large paintings in the chapels of the Sassetti in Santa Trinità and of the Tornabuoni in Santa Maria Novella; the frescoes depict rows of portraits of family members. In addition he created some of the most fascinating individual portraits of the Early Renaissance in Florence.

There was already a tradition in Florence of portraying young, beautiful and upper-class women in profile. This was the pattern that Ghirlandaio chose when he received the commission to paint Giovanna degli Albizzi Tornabuoni. Although there is no inscription naming her as the sitter, she can be identified by a portrait medal. On the *cartelino* of the painting, a sticker in the background, an inscription proclaims: ARS VTINAM MORES / ANIMVMQVE EFFINGERE / POSSES PVLCHRIOR IN TER / RIS NVLLA TABELLA FORET / MCCCCLXXXVIII (cf. translation below). The inscription should be read both as a glorification of the beauty of the lady, and of the painted panel *(tabella)*. A typical phrase in praise of women, it should be understood as meaning that there is no artistic means of capturing such beauty in its entirety, and so Ghirlandaio created at least the best-possible portrait.

The dating of the inscription, 1488, represents a *terminus ad quem,* for Ghirlandaio only ever dated a work by its completion. There is much to suggest that the painting was done before the beginning of October 1488, for Giovanna died shortly afterwards giving birth to her second child. The occasion of the commission could have been the marriage in 1486 or the birth of the first son in 1487. The assumption that the profile portrait necessarily implies a memorial picture of the deceased is not supported by any mortuary symbolism in the picture itself, nor by the inscription, for such a laudation would certainly have to refer to the fact. Not long after, Ghirlandaio used this portrait as the model for his depiction of Giovanna in the family chapel in Santa Maria Novella, where he painted the frescoes between 1486 and 1490. According to an inventory, the panel painting was still in one of the rooms of her husband Lorenzo Tornabuoni in the Florentine palazzo in 1498.

Giovanna is depicted in a fictitious room, with an alcove behind her, in which can be seen a brooch on the left and a book on the right with a coral necklet above. This arrangement parallel to the plane of the room supports the static calm of the sitter's posture. The neutral expression concentrates attention on the fine profile of the face. The fashionable ideal of beauty at the time is revealed in the high forehead raised by shaving the hairline, the long neck, the elaborately plaited hair with an additional hairpiece *(cuffia)* and the magnificence of the clothing. Everything matches her status. Giovanna is wearing a sleeveless overdress *(giornea),* which is open to the front and sides, with an ankle-length lozenge-patterned underdress *(cotta)* over a white shirt *(camicia).* Around her neck she has a pendant with a flat stone decorated with three pearls. Her fingers are adorned by a number of rings. The white handkerchief in her hands is merely a modish accessory, which in *quattrocentro* Florence had become a sign of feminine elegance.

"Art, couldst thou reproduce morals and spirit, no other panel on earth would be so beautiful."

Translation of the inscription in the background of the panel with the portrait of Giovanna Tornabuoni

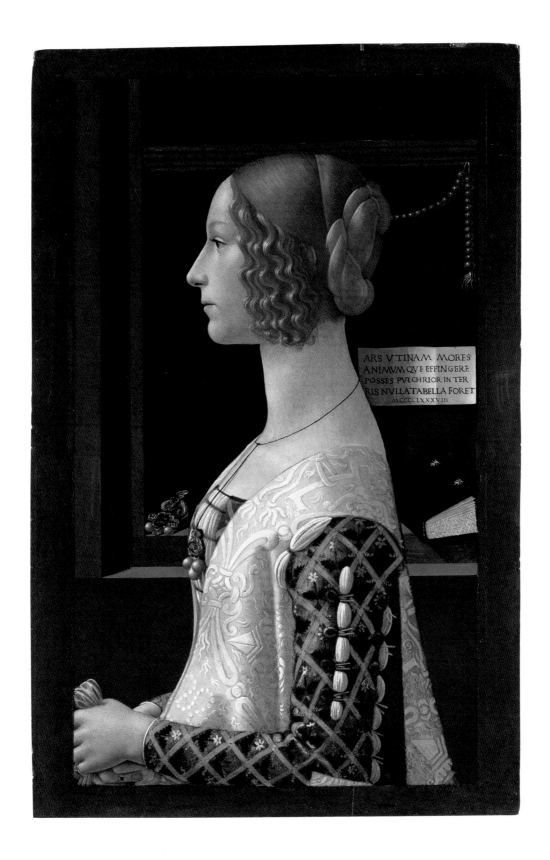

ARS VTINAM MORES
ANIMVMQVE EFFINGERE
POSSES PVLCHRIOR IN TER
RIS NVLLA TABELLA FORET
MCCCCLXXXVIII

portrait of oswald krell

Mixed media on wood, triptych: 49.3 x 15.9 cm; 49.6 x 39 cm; 49.7 x 15.7 cm
Munich, Bayerische Staatsgemäldesammlungen, Alte Pinakothek

**b. 1471 in Nuremberg
d. 1528 in Nuremberg**

Albrecht Dürer, known as "Appelles Germaniae" and thus as the German counterpart of a famous painter of Antiquity, had already revealed his talent as a portraitist while still a boy. From Nuremberg he went on journeys to the Netherlands and to Italy. Even before the new century had begun, he had developed his early portrait style, a sober naturalism concentrated on the individual.

Dürer's portrait of the merchant Oswald Krell (spelling of the inscription: Oswolt Krel, 1499) from Lindau on Lake Constance is regarded as the most mature achievement of this early phase.

From about 1495 to 1503, Krell was working in Nuremberg as the agent of a Ravensburg trading company. Back in Ravensburg, he headed the company until he returned to Lindau, where in 1512 he became "town captain" and in 1514, mayor. He was thus a typical patrician client, whom Dürer portrayed with all the seriousness due to a young, successful merchant on the make.

Krell is depicted half-length against a red curtain, which is open on the left to reveal a landscape with trees. This combination of close-up portrait and landscape view can be found frequently in Dürer's works between 1497 and 1499, most prominently in his self-portrait of 1498 (Madrid, Museo del Prado). Krell is shown in three-quarter profile looking slightly downwards, as if he were closely watching something. His still young face is framed by shoulder-length curly hair, which is not covered by any headgear. The tunic is open far enough to reveal an expanse of chest, adorned with a necklet, down to the hem of the white shirt. Around his shoulders he has a black cloak with a fur collar, which he is holding together with his left hand, while his right, it would seem, is resting casually on a balustrade.

The side panels of the triptych served formerly to protect the portrait, covering it when closed. On the left panel is the Krell coat-of-arms, on the right that of his wife Agathe von Esendorf. The supporters are two "wild men", which at this period were often used thus as popular fabulous beings. This particular type of private portrait with a protective cover, whether in the form of hinged or sliding panels, was very widespread.

More than a quarter of a century later Dürer painted what is perhaps his strangest portrait. The sitter was likewise a merchant and banker Hans Kleeberger (Johann Kleberger), a native of Nuremberg who had made his fortune in business in France and Switzerland. Back in Nuremberg since 1525/26, he sought every opportunity to achieve recognition in better circles. The occasion for the portrait was his proposal of marriage to the eldest, recently widowed daughter of Willibald Pirckheimer. The small panel, dated 1526, is the programmatic picture of a social climber who had grown rich as an international financial broker. He had himself painted by Dürer to his own design as a man who owed his success to the stars; his likeness has been deciphered as the image of a "lion character" with a humanistic education and the self-styling of a *nouveau riche*. With this late work, Dürer succeeded once again in creating a masterly synthesis of his ability to monumentalize faces.

Johann Kleberger, 1526

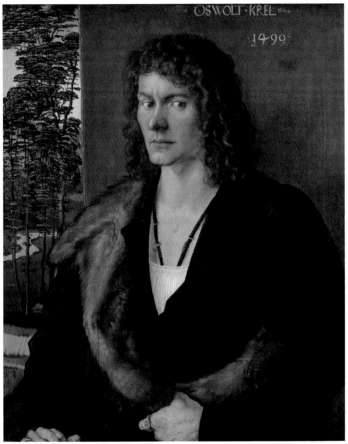

Mona Lisa (La Gioconda)

Oil on wood, 77 x 53 cm
Paris, Musée National du Louvre

b. 1452 in Vinci (near Empoli, Tuscany)
d. 1519 Cloux in (near Amboise, Loire)

We know almost nothing for sure about Leonardo's portrait of Mona Lisa, perhaps the most famous picture in art history. One major source is Giorgio Vasari, to whom we owe the name, although it must be said that not only had he never seen the picture himself, but also he knew neither the artist nor the client personally. The sitter is the wife of the Florentine silk-merchant Francesco del Giocondo, hence the alternative name "La Gioconda". The hypothesis that it might be a portrait of Isabella d'Este, the woman who probably sat for a profile by Leonardo, is now discounted.

The picture was probably commissioned in 1503. The occasion was possibly the birth of a second son to the Giocondo family and their move to a new house. The assumption is that Leonardo worked on the painting between 1503 and 1506, while he was in Florence. Contemporaries must have realized immediately that a masterpiece was in the making. Raphael, who visited Leonardo in his workshop, took up this portrait type in his own work at this period. What is strange is that the painting remained in Leonardo's possession for the rest of his life, perhaps because the complicated technique prevented it from being finished for years. The background landscape in particular supports the assumption that Leonardo worked on the picture until at least 1510. In any case the *Mona Lisa* came into the possession of King Francis I of France at Fontainebleau shortly after Leonardo's death in 1519.

Vasari's description, which dates from 1550, represents the first episode in the sensationalism which has accompanied this portrait like no other. He praised the beauty of the sitter, the painting technique, and Leonardo's meticulous care, which in delicacy and vitality exceeded anything seen hitherto. One could, he said, see the shimmer of the moist shine of the eyes and the veins beneath the skin, as well as the pulse in the neck. The magical expression of the face provoked Vasari into a pun whose consequences led to a puzzle that has lasted for centuries. Leonardo had only managed the famous Mona Lisa smile, he said, because during the sittings he engaged singers, musicians and comedians to keep the lady amused. Vasari consequently praised the "amiable smile" in the highest terms, as it seemed more heavenly than human. Leonardo's warm-up measures might have put both his sitter and himself in the requisite mood. Vasari's predilection for linguistic jokes suggests that the "smile" could be a punning allusion to her name "La Gioconda", the cheerful one, derived from the Latin *iocundus,* from *iocus,* "joke". Countless interpretations would then be reduced to Leonardo's having striven to portray a cheerful creature. Allusions to the ideal beauty of Madonna pictures should also be considered.

With this portrait, Leonardo consummated the Florentine female portrait of the High Renaissance. Mona Lisa is shown half-length, her hands one over the other on a balustrade, and framed on either side by cropped columns. The broad landscape in the background is important; it does not depict the Florentine hinterland, but offers a summary view of the world. It is a splendid example of Leonardo's *sfumato* painting technique, the smoky soft-focus veil which shrouds things in a diffuse atmosphere.

"Mona Lisa was very beautiful."

Giorgio Vasari, 1550

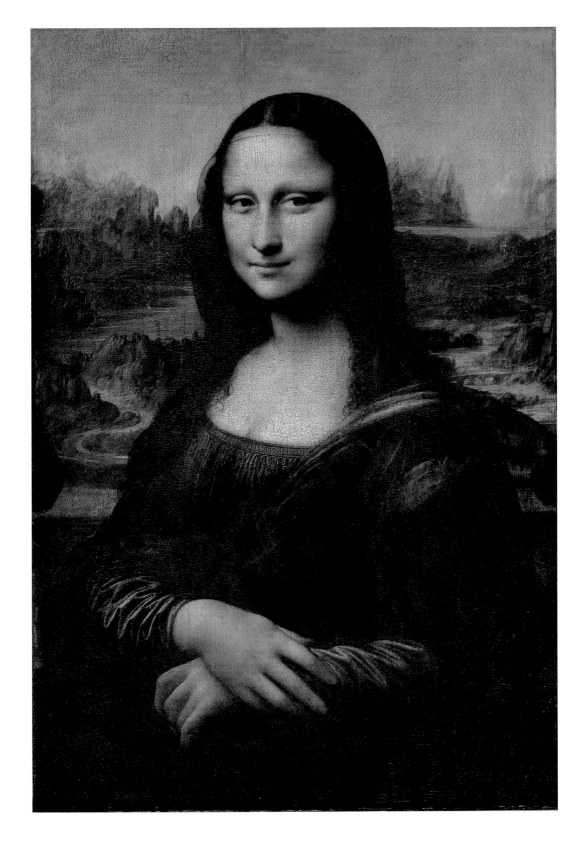

Portrait of a young woman (La Fornarina)

Oil on wood, 87 x 63 cm
Rome, Galleria Nazionale d'Arte Antica di Palazzo Barberini

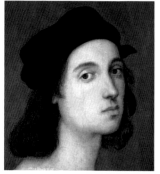

b. 1483 in Urbino
d. 1520 in Rome

Art history also has its *chronique scandaleuse*. Raphael was a painter who had seemed to succeed at everything from his childhood on. At the zenith of his career in Rome he was to be married, but he came up with various excuses to walk out of the planned union. Instead, he was said to have had a steady lover and to have led a colourful love-life on the side. With unproven anecdotes like these, Giorgio Vasari conjured up enduring speculations as to who this lover might have been. Later interpreters liked to think it might have been Margherita Luti, who was also said to have been Raphael's model. She was the daughter of a Roman baker, hence "La Fornarina". None of the female portraits by Raphael gave rise to fantasies in the way that this one did. But there is no historical probability that this painting depicts Raphael's lover.

An attractive young woman is sitting "topless" for a painting. She has a red cloth draped over her hips, and a diaphanous veil in front of her bosom, which only serves to draw more attention to her nudity. She is not looking at the beholder, but has her head turned slightly to one side, as though she were watching something. Her hair is elaborately done up in a sort of turban, from which a pearl is hanging. Most striking of all, however, is the circlet on her left upper arm, which in golden letters bears the signature RAPHAEL VRBINAS. No other portrait was signed by him in such an emphatic manner, which is why it has been read as evidence of a personal relationship.

A private occasion for nudity in a picture was at that time totally unthinkable; one always needed some mythological or allegorical excuse. Nudity as an attribute is a privilege of Venus. It is conceivable that Raphael on the one hand was painting nudity as an expression of beauty, and on the other was striving for a verist and sensuous depiction of his model.

Raphael formulated this artistic problem in a now famous letter dating from 1514 to the courtier and womanizer Baldassare Castiglione. Castiglione had been writing his *Libro del Cortegiano* (Courtier's Book) since 1508, which was to be a bestseller for centuries and was translated into many languages. In it he described in dialogue form the behaviour code of courtesy *(courtoisie)* through the aristocratic stiff upper lip, perfect manners, witty praise of women, extensive knowledge of literature, art and science as well as such chivalrous competencies as dancing and fencing. Raphael wrote to Castiglione that to paint his *Galathea* (1512 fresco in the Villa Farnesina, Rome) he would have had to see many women in order to paint them as the ideal of beauty. But because this was not possible, he had made use of a "certain idea" that had come into his head. He went back to an anecdote from Antiquity: the Greek painter Zeuxis was commissioned to paint a picture of Helen for the Temple of Hera in Kroton (Pliny says it was a picture of Hera for Agrigento). As no model totally matched his idea of beauty, he summoned five virgins, and chose the most beautiful feature of each. Raphael too created a synthesis that matched his ideal, namely that the beauty of woman, as of painting, sprang from a higher principle.

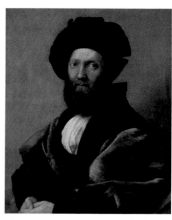

Baldassare Castiglione, 1514–1515

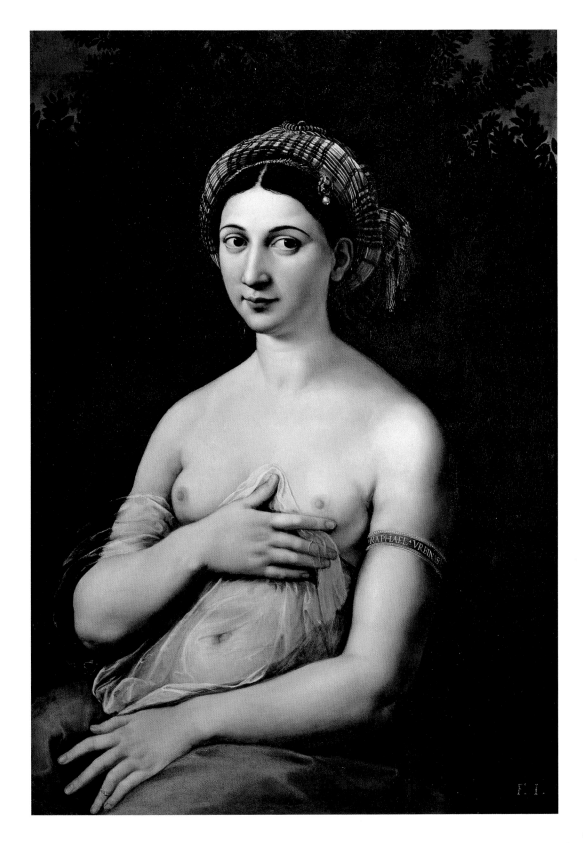

ᴊean de ᴅinteville and ɢeorges de selve (ᴛhe ᴀmbassadors)

Oil on wood, 207 x 209.5 cm
London, The National Gallery

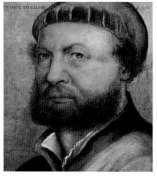

b. 1497/98 in Augsburg
d. 1543 in London

In his career as a painter, Hans Holbein had already achieved everything there was to achieve when he received the commission for this unique double portrait. He had begun his training in Augsburg under his father. After moving to Basle in 1515, he was much in demand as a portraitist among merchants and humanists, and achieved an international reputation. He executed commissions in France in 1523/24, and spent the years between 1526 and 1528 in England, where he finally settled in 1532. Based in London, he was appointed court painter to King Henry VIII in 1536.

In the spring of 1533, Holbein was commissioned by Jean de Dinteville, Sire de Polisy, to paint a double portrait of him together with his friend Georges de Selve, who was currently visiting. In that year Dinteville was the ambassador of King Francis I of France to the English court. The portrait was destined for Dinteville's château at Polisy. The theme is on the one hand the friendship of the two men, expressed through complex symbolism, and on the other Dinteville's personal motto: *memento mori.*

The two men are posing in an imaginary room beside a table full of scientific instruments and books against the backcloth of a green curtain. On the extreme left a crucifix is hanging on the wall. The floor is unique in England. Known as the Cosmati Pavement, it was created in 1268 for the chancel of Westminster Abbey by Master Odoricus, who had been trained in Italy. This was the venue of the marriage for which Henry VIII was prepared to break with Rome. The friends have had themselves depicted in official garb. On the left, Dinteville is in festal diplomatic garments with the Order of St Michael, on the dagger the indication of his age: 29. To the right of the table is Selve, in the dark, fur-trimmed gown of the cleric and scholar, he too with a mention of his age (25) on the side of the book next to him.

In this double portrait Holbein demonstrates, as he does in his 1532 portrait for the *Merchant Georg Gisze* (Berlin, Staatliche Museen zu Berlin, Gemäldegalerie), the ambitious interest of the client to illustrate a personal message with a picture filled with symbolic clues. The numerous instruments reveal the scholar-ideal of the two friends and embody the *quadrivium* of liberal arts: music (lute, flutes, songbook), arithmetic (the commercial calculation book by Peter Apian, 1527), geometry (dividers, protractor) and astronomy (celestial globe). All the objects have a subtle relationship with the sitters. Mysterious at first sight is the curious amorphous object hovering over the floor, which turns out to be a skull, rendered in anamorphic perspective. It can be seen in its proper shape from a position to the right of, but almost in the same plane as, the picture. Educated connoisseurs would thus pick up the reference to Dinteville's motto. In addition, the cylindrical calendar, known as a dioptre, gives a precise date: 11 April 1533 at 9.30 or 10.30 a.m. This suggests a specific moment for the scene which is however as fleeting as time itself, so that one should be aware of one's own transience. The client and painter realized a scholarly programme picture full of riddles. For all the glitz of high office and dignity in politics, religion and science, the humility of one's own existence is stressed.

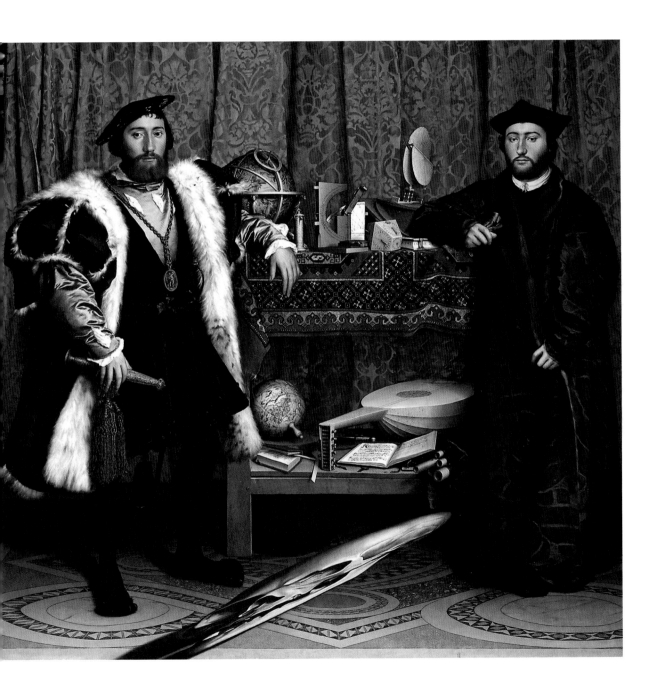

Portrait of a Young Lady (so-called Antea)

Oil on canvas, 139 x 88 cm
Naples, Museo e Gallerie Nazionali di Capodimonte

**b. 1503 in Parma
d. 1540 in Casalmaggiore
(near Parma)**

Francesco Mazzola, known as Parmigianino after his home town of Parma, was a highly talented and artistically precocious painter, in whom some contemporaries sought to see a reincarnation of Raphael, who had died young. They saw him as blessed with unparalleled talent, which however he wasted first through his louche lifestyle, and later in alchemist experiments.

Following a meteoric start to his career, not least with his famous *Self-portrait in a Convex Mirror* (1524; Vienna, Kunsthistorisches Museum), he arrived in Rome in 1524 and enjoyed immediate success, albeit not at the papal court. The plunder of the city by imperial troops in 1527, an event which has gone down in history as the "Sack of Rome", caused him to return to Parma, where he created all of his most important paintings from then on. Here he painted the portrait of the young lady whose identity remains unknown to this day; the name "Antea" is a fiction, but will doubtless stick.

A story dating from 1671, that it represents Parmigianino's lover, lacks any evidential plausibility. Antea, who is mentioned in the autobiography of Benvenuto Cellini, and also in the writings of Pietro Aretino, was a popular courtesan in Rome. It is easy to imagine that the beauty of the young lady gave rise to the speculation that she was romantically linked with her portraitist Parmigianino, not least on account of the fascination exercised by the portrait. Stylistically, the painting cannot be dated to Parmigianino's sojourn in Rome; the painting is more likely to have been executed in Parma in c. 1535, the time at which his *Madonna with the Long Neck* (c. 1534/35; Florence, Uffizi) was also painted. Some people have even claimed to see a striking resemblance between "Antea" and an angel standing next to this Madonna, which suggests that the young woman could have been a studio model, and not just a sitter for her own portrait.

The type suggests an official commission. The lady is dressed in elegant clothes, with a yellow dress made of atlas silk. The top is patterned with lozenges, while from the hips down she is wearing a narrow white apron. Over her right shoulder, which curiously is far too broad, she is wearing a pine-marten fur stole complete with head. The animal's nose is pierced with a ring on a chain, which she is holding in her gloved right hand, while the other hand is bare, and is grasping a necklet at stomach height. On her little finger, in her ears and in her precisely styled hair, she is wearing further costly jewellery. There is absolutely no doubt that importance was attached to the depiction of the expensive fabric and of the lady's wealth, so that, if we exclude the courtesan thesis, she must be a lady of rank. Her youth suggests that she was still unmarried. In other words it was a normal commission, in which Parmigianino could demonstrate his talent for depicting youthful beauty, such as was stylized in contemporary poetry as the ideal of the courtly praise of women. Youth and grace, with and elegance, charm and culture, breeding and *courtoisie* were the elements of a poetically inspired ideal of beauty which was ubiquitous as a result of 16th-century Petrarchism. What sets Parmigianino's portrait apart is its extraordinarily brilliant coloration. For all the detachment which normally reproduces the social status of his sitters, Parmigianino always succeeds, with a psychological feeling for nuances, in capturing something individual.

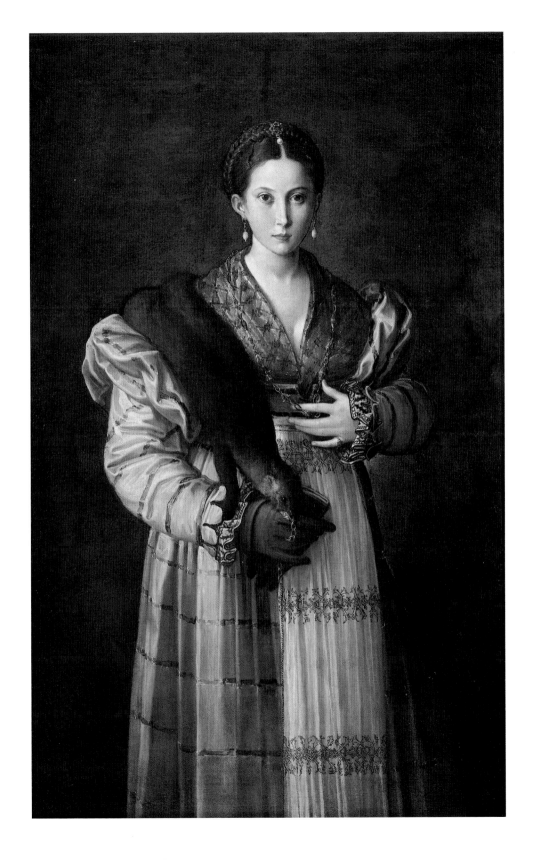

pope paul III and his grandsons

Oil on canvas, 210 x 174 cm
Naples, Museo e Gallerie Nazionali di Capodimonte

b. circa 1490 in Pieve di Cadore
d. 1576 in Venice

Titian was one of the most sought-after portraitists of his age. Emperor Charles V had bestowed the title of Court Painter upon him, and allowed no one else to paint his portrait. No wonder that in Rome it was likewise considered appropriate for the pope to be portrayed by Titian. The circumstances were, it is true, complicated, and ultimately Titian's unfinished portrait of Pope Paul III Farnese with his two grandsons Ottavio and Alessandro Farnese tells a story of failure. Titian was never paid for this picture, and he left it unfinished in Rome in May 1546. There had been attempts to get him to reduce his price, and the hope that he would accept the assurance of church perquisites from a parish treasury for his son in lieu of cash payment was also disappointed.

We may presume that Cardinal Alessandro Farnese, who was in contact with Titian, prepared the way for this commission. The painting was intended as a demonstration of the family ambitions of the Farnese. Papal nepotism had already been the subject of pictures by Raphael, but Titian expanded the concept of the papal state portrait by including both action and full-length depictions. The 77-year-old pope is sitting with his head sunk deeply into his shoulders at a table with a red tablecloth, on which is standing an hourglass. Time runs out even for popes, is the message of this *memento mori*. On his head the pontiff is wearing the *camauro,* the cloth cap edged with fur. Around his shoulders is a *mozzetta,* a red shawl with a small hood, likewise edged with fur. Beneath it, the pope is wearing a gown lined with ermine and buttoned in the middle.

Approaching from the right is Ottavio Farnese, dressed in a short doublet, puff hose and white stockings, with a broad fur cloak over his shoulders. He is paying homage to the pope, bowing ceremo niously in the prescribed fashion, holding his right hand with doffe cap in front of him, while the left hand touches his sword. He has to d this three times, ending the last performance by kissing the pope's too From the left, the 26-year-old Cardinal Alessandro is grasping th back of the chair, shrouded in his cardinal's robe, worn over the whit rochet reserved for high dignitaries of the Church. Both young rela tions embody the political ambitions of the pope, Alessandro as th candidate for the highest positions in the curia, Ottavio as his tempora counterpart. Titian has not only demonstrated his psychological sens for power-oriented nepotism, but also the internal fragility of individua interests. And yet an examination of the painting technique shows tha he tried to meet the client's wishes in order to achieve his own ends.

Somewhat more than a hundred years later, Velázquez portraye Pope Innocent X in Rome, for his part in the hope of obtaining papa support for his admission into the order of Santiago, a hope which wa fulfilled. Even more than Titian, Velázquez was a brilliant exponent o nuances of red, and he depicts the lurking distrust in the expression of a power-oriented individual even more intensely.

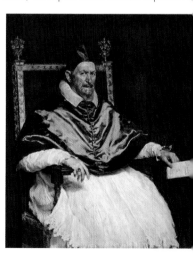

Diego Velázquez, Pope Innocent X, 1650

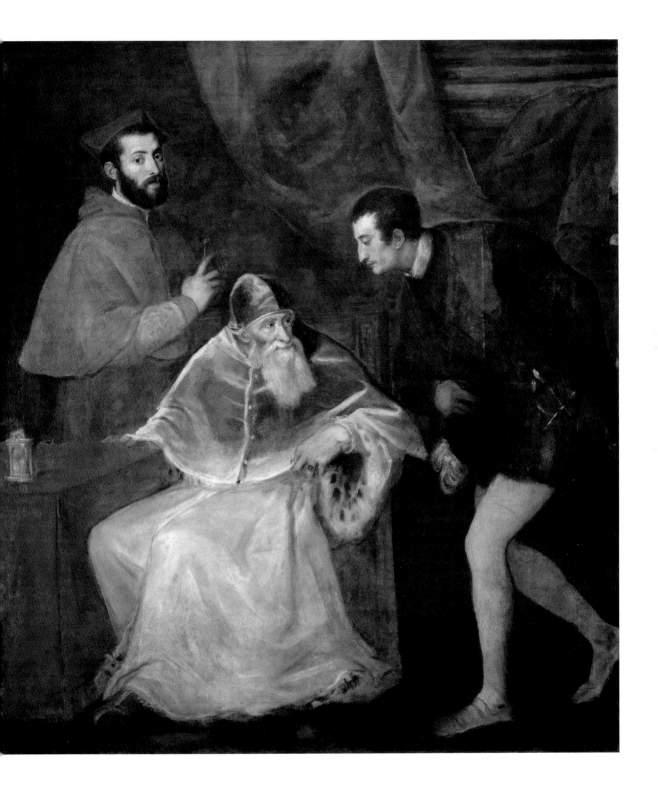

тне тailor

Oil on canvas, 99.5 x 77 cm
London, The National Gallery

b. 1520/24 in Bandio (today Albino, Bergamo province)
d. 1579/80 in Bergamo

Moroni was one of the most accomplished portraitists in Lombard painting in the 16th century. For a long time he did not obtain the recognition he deserved, because some of his best portraits were attributed to Titian. His teacher was Moretto da Brescia (Alessandro Bonvicino), likewise a skilled portraitist. There is no documented evidence of Moroni ever having visited Venice, but his œuvre demonstrates that he was familiar with the work being done there.

Moroni's portrait shows a tailor. His clothing is not that of an artist, nor of an aristocrat, but of the middle class, so it is possible that he was also a cloth-merchant. It is clearly an early example of the professional portrait. Very few earlier portraits can be thus classified. Moroni was a pioneer in this field. Already by 1552/53 he had painted the sculptor Alessandro Vittoria in his working clothes, his lower arms bare (Vienna, Kunsthistorisches Museum), and he made no secret of the fact that this artist has to roll up his sleeves. Moroni's portraits carried conviction through their authenticity. Later, Marco Boschini, in his didactic poem *La Carta del Navegar Pitoresco* (1660), paid homage to the successful vitality of Moroni's tailor. Moroni demonstrates an astonishing naturalism, which inspired many interpreters to see this painting as the expression of an everyday scene, and even to go so far as to make comparisons with 19th-century works. But the criteria for naturalism or realism in the modern period cannot be transferred to an earlier era. However, it is certainly noteworthy that such occupational portraits could be painted at all in the mid 16th century, depicting, as they do, the middle class. An indication for the growing popularity of this new genre is provided by a letter written by the *literato* Pietro Aretino in 1554, in which he complains that these days even people like tailors were having themselves immortalized in portraits. Moroni's tailor, however, may well have been a special case, for his belt has an attachment for a sword, obviously a privilege. The sitter may have been the Master of a guild.

In any case, the action in itself is unusual, for no attributes of a particular office are depicted, but rather a craft activity. This activity is ennobled by the painterly quality, which would be worthy of a person of rank. It is precisely this which is innovative. The depiction of persons carrying out a typical action associated with their trade may in such a case be seen as the simulation of a realistic everyday scene. Everyday scenes, it is true, only became picture-worthy during these decades. Upper Italy is seen as the region where early genre painting developed, and also where persons of lesser rank were regarded as worthy sitters. We owe pioneering examples in particular to Annibale Carracci, who in about 1580/90 painted peasants and ordinary people. A little later, at the turn of the century, Caravaggio, who came from the same region, drew on these inspirations. Moroni may be seen as a forerunner.

> **"тне тailor, so beautiful, so well executed / а likeness more eloquent than words of any lawyer / тне shears are in his hands: we watch where he will cut."**
> **Marco Boschini, 1660**

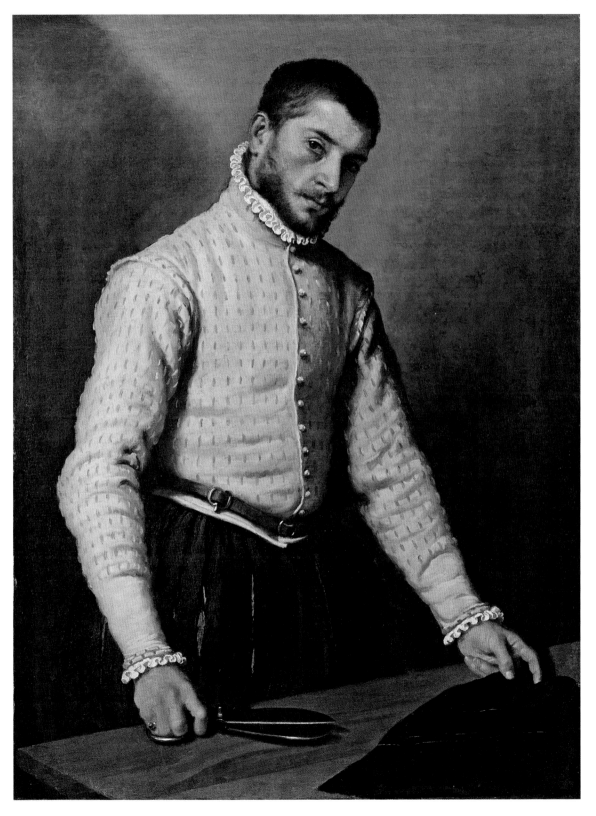

Emperor Rudolph II as vertumnus

Oil on wood, 68 x 56 cm
Balsta (Sweden), Skokloster Castle

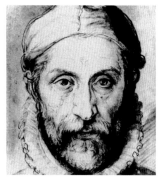

b. 1527 in Milan
d. 1593 in Milan

Giuseppe Arcimboldo began his career at the Vienna and Prague courts under Maximilian II and Rudolf II as a portraitist in 1562. He made such an impression as an impresario at court festivities, as a designer of costumes and party devices, and as an adviser in matters concerning the art cabinet that he was ennobled in 1580, and finally, in 1592, in gratitude for his two last paintings *Vertumnus* and a *Flora* was awarded the title of Count Palatine. Arcimboldo's fame as a painter was based above all on the novel composite heads which he invented for cycles for the seasons and the elements. The first such paintings, which date from 1563, are part of the cycle of seasons. The systematic interlacing of several layers of meaning is fully developed from the outset. The pattern of personifications is modified to the extent that while the human figure provides the basic shape, it is composed of things that relate directly to the theme.

In many cases the composite heads are also meant as portraits. The painting of *Vertumnus* personified the classical vegetation god of seasonal change through the tried and tested technique of numerous fruits. The first level of meaning is the personification of the vegetation, in other words of the god Vertumnus, which Arcimboldo succeeds in achieving through formal analogies between the individual forms of the head and the fruits and plants. On a further plane of meaning, this leads to an allegory, as the design of the composite head also relates to a specific person, namely Emperor Rudolph II. The formal analogies between Arcimboldo's *Vertumnus* and the actual appearance of Rudolph II, as we know him from other portraits, are convincing and would almost certainly have been recognized without explicit hints. Other allegorizing portraits by Arcimboldo also went down very well at

court. Gregorio Comanini, who shared a house in Milan with the old Arcimboldo, describes the merriment among Maximilian II and his courtiers when Arcimboldo presented the portrait of a Doctor of Jurisprudence, who in real life was disfigured by syphilis and whose face in the painting consisted of roast meat and fish.

A core point in the understanding of Arcimboldo's paintings lies in the meticulous imitation of nature and the underlying understanding of nature, which sees the possibilities of combining unrelated objects as already present in nature. The respective individuality of the objects is skilfully examined to see how it might be transferred to the different context. In the process, natural proportions are abandoned in favour of functional integration. The assumption of an objective sensory perception and thus the idea of the absolute exemplary nature of the natural world is however revealed, in the imitation, as a fiction. Things are represented as what they are, but at the same time they are something else.

An important role here is played by irony. It characterizes things that are different from each other but which can be mutually illuminating, and in a way that tends towards parody, the comical and the burlesque. Certainly the monstrous aspect of Arcimboldo's paintings may be attributed in no small measure to an understanding of nature that sees hybrid forms on the borderlines between art and nature. But on the other hand we cannot overlook the irony which consists in the demonstration of a comic relationship of what in fact are dissimilar objects. Seen in this light, the composite technique turns out to be a means to a particular end, which consists in the ironic alienation of nature as perceived.

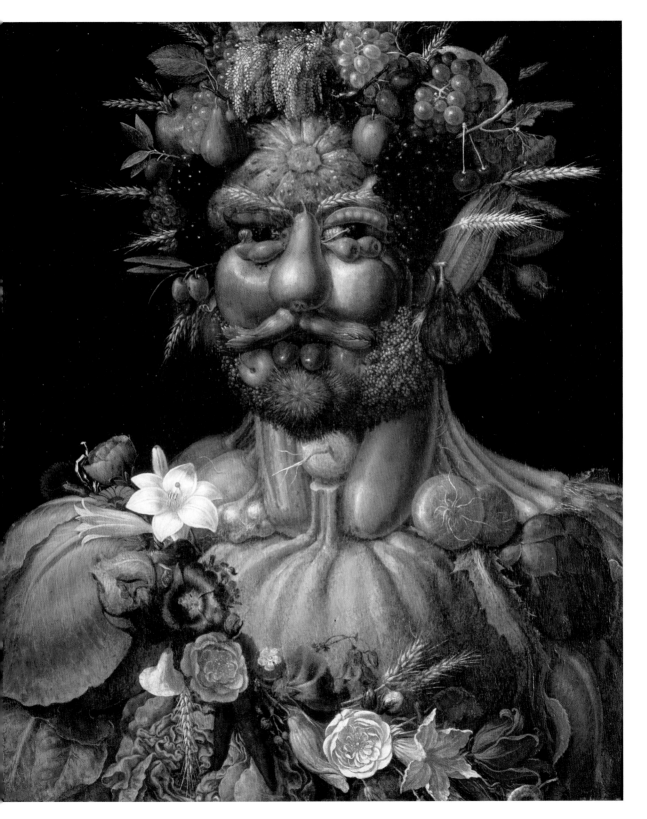

Hélène Fourment (Het Pelzken)

Oil on wood, 176 x 83 cm
Vienna, Kunsthistorisches Museum, Gemäldegalerie

b. 1577 in Siegen
d. 1640 in Antwerp

Already lionized throughout Europe as a painter, Rubens married for the second time on 6 December 1630. His bride, Hélène Fourment, was just 16, a circumstance that led to much imaginative speculation that Rubens had succumbed to a fit of infatuation. But there would seem to have been quite sober preparations for the marriage, in keeping with the custom of the time. That love played a role, though, is suggested by the numerous portraits of the young lady, and the other paintings in which she sat as model. Already the portrait that was painted to commemorate the wedding and shows her in a wedding-dress bears witness to more than just affection. Her eyes are all for her husband as he paints: frankly, seriously and yet lovingly she gazes at him. Professional panegyrists praised her beauty, and indeed she seems to have lived up to the contemporary ideal. Rubens in any case staged her as a goddess in numerous paintings. Totally nude, she embodies the ideal image of beauty as Venus in the Madrid version of the *Judgement of Paris,* in the judgement of whose court she was no less the winner than Venus was in the eyes of Paris.

Nudity as an attribute of mythological beauty, which provided its "justification", was by no means new, but for Rubens the unusual picture of the naked Hélène is exclusively private in character. Hélène is standing on a red cloth and is wrapping herself, apparently spontaneously, with a white cloth and a fur cloak. She is holding both in such a way that each arm crosses in front of her body, covering the pelvic region, but pushing her breasts up in the crook of her right arm. Here, together with the face, the intimate gaze of the painter is betrayed. The title *Het Pelzken* ("The Little Fur") is due to Rubens himself, who described the painting thus in his will. He bequeathed it as a separate

item to his wife and also stipulated expressly that it should not be offset against her official share of his estate. It was only after her death in 1658 that it passed into other hands.

As though they had an Impressionist picture in front of them, art critics erroneously thought for a long time that Rubens had caught his wife climbing out of the bath and was fascinated by the scene. But this should not be seen as a spontaneous snapshot. The careful coiffure alone speaks against such an interpretation: it is designed to heighten the impression of her face and her responsive gaze. Once again Rubens is staging his wife as a goddess, this time as a synthesis of various Venus types. Her attitude is reminiscent of the *Venus pudica,* the modest Venus hiding her breasts with one arm and her sex with the other, the famous model for many artists being the classical statue of the Capitoline Venus in Rome. One might also think of the type represented by the Aphrodite of Cnidus, who is undressing for her bath and covering her pubic region. The fur also relates to the *Venus frigida,* the freezing Venus, warming herself after her bath. Another model for Rubens was Titian's painting of a semi-nude girl in a fur (Vienna, Kunsthistorisches Museum), his knowledge of which is documented. Rubens' picture in other words is anchored in traditional iconography, and yet the picture remains a very personal homage to the beauty of his wife.

Hélène Fourment in Wedding Dress, 1630–1631

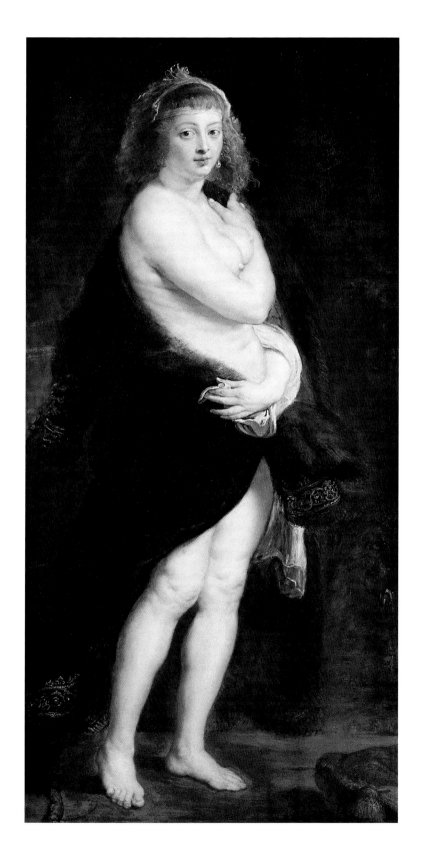

captain Frans Banning cocq with Retinue (The Night watch)

Oil on canvas, 363 x 437 cm
Amsterdam, Rijksmuseum

b. 1606 in Leiden
d. 1669 in Amsterdam

Rembrandt's group portrait of a company of Amsterdam civic militia is a high point of a genre that was particularly important in the Netherlands. Various professional groups or guilds had group portraits painted for their institutions, the sitters contributing to the cost in proportion to their rank. Another famous example is Rembrandt's *Anatomy Lesson of Dr Nicolaes Tulp,* in which he shows that medical education was based on the textbook by Vesalius.

The name "Night Watch" is wrong and based on an erroneous interpretation of the lighting: the only reason the picture looked like a night scene was that the numerous layers of varnish had darkened. It is however a daytime scene with natural illumination and Rembrandtesque chiaroscuro.

The sitters are Captain Cocq with Lieutenant Willem van Ruytenburgh and members of the civic militia. These militia companies were also known as "Kloveniers", or arquebusiers, after their typical weapon, the arquebus or musket. Shooting practice was always linked to assemblies in the guild houses, which were known as "doelen". The Kloveniers guild built a new Kloveniersdoelen in the Nieuwe Doelenstraat in the 1630s. Between 1638 and 1645 a total of seven group portraits were commissioned for the decoration of the banqueting hall. It has been possible to reconstruct the hanging of Rembrandt's painting; the picture was subsequently cropped.

This commission required changes in the traditional standards in group portraiture Rembrandt shows a typical action, doing justice to the roles, and not a static banqueting picture. On the instruction of Captain Frans Banning Cocq (dressed in black with a red sash), Lieutenant Willem van Ruytenburgh (yellow, to his immediate right) gives the company its marching orders. The captain is thus assembling the group behind himself, the company is only just beginning to form up, but the order of march has not yet crystallized. Rembrandt's composition illustrates this movement of coming to order. The officers are pushing into the middle of the picture, the positions of many muskets and lances suggests the military line-up. In front of a wall with an arched opening, the militia are forming up in various groups around two "lanes", which bring depth into the composition and emphasize the protagonists with the lighting. On the right is a drummer, to give acoustic support to the command, who anticipates the march formation Rembrandt has portrayed 18 guild members, but by adding further figures, has created the illusion of a full-strength company with a hierarchy demonstrated in characteristic action.

Disputed interpretations have been triggered by the brightly lit girl, who is regarded as a market stallholder. Rembrandt hit upon the idea of representing her so to speak as the allegorical embodiment of the guild. On her belt she is carrying a chicken, whose claws are visible, while the head is concealed. The emblem of the guild consisted of a claw and a musket. The "Kloveniers", the arquebusiers, were named after the "kloven", or butt, of the arquebus or musket, and the claw is a pun on their name (clawveniers). The girl is additionally carrying the guild's costly drinking horn, something that can only be explained by her allegorical function. Thus, what we have is a scenic event picture with historical portraits and the allegorical representation of the guild as a corporate institution.

The Anatomy Lesson of Dr Nicolaes Tulp, 1632

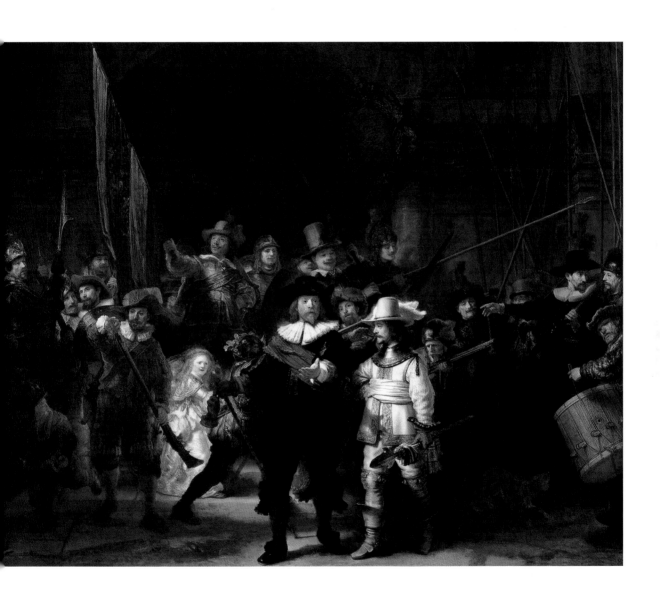

Las Meninas

Oil on canvas, 318 x 276 cm
Madrid, Museo Nacional del Prado

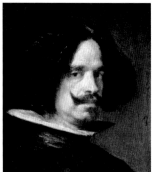

b. 1599 in Seville
d. 1660 in Madrid

Diego Velázquez had almost arrived at the zenith of his career. His last goal was to be admitted into the order of the Knights of Santiago. After this wish had been fulfilled, he retro-painted the emblem of the order on to his gown in this picture. The great painting *Las Meninas* is one of the most-admired group portraits in the history of art. Luca Giordano, later also a court painter in Madrid, opined in 1692 that it showed "the theology of painting".

In a room in the Alcázar in Madrid, where Velázquez was allowed to set up a studio, we see the heiress to the throne, the Infanta Margarita, with her courtiers. The art historian Antonio Palomino named all the persons in the 18th century: kneeling at the Infanta's feet to her left, Doña María Agustina Sarmiento, the queen's maid-of-honour *(menina)* is offering the princess a jug of water. Behind the latter stand the lady-in-waiting Doña Isabel de Velasco, and next to her the grotesquely misshapen dwarf Mari Bárbola and another dwarf, Nicolasico Pertusato; the latter is using his foot to prod the dog lying in front of the group, in order to demonstrate the sleepy mastiff's amiability. Further in the background, almost hidden in the shadows, there is an unidentified *guardadamas,* a guard for the court ladies, and the lady-in-waiting Doña Marcela de Ulloa.

Velázquez himself is seen standing with brush and palette in front of a tall canvas which we can only see from behind. Large pictures are hanging on the back wall of the room. In a dark frame beneath these pictures can be seen – presumably in a mirror – the parents of the princess, the royal couple. To the right of the mirror, on a staircase leading to a door and a brightly lit room to the side, stands José Nieto, the queen's chamberlain.

Although the Alcázar burned down in 1734, it has proved possible to localize the scene in the ground-plan of the palace. The reconstruction of the room itself, however, has been controversial. The greatest confusion, certainly, has been caused by the mirror on the rear wall, in which some have sought to see a painted canvas: in other words Velázquez was depicting himself portraying Philip IV and his consort. For a fact, the social position of a court painter who conspicuously includes himself in the picture and thus in the circle of the royal family, is not without its problematic aspect, especially as the king and queen themselves are only shown indirectly. But Palomino reports that the monarch was particularly pleased with *Las Meninas* after its completion. This implies that Velázquez must have paid attention to the rules of etiquette in his painting.

The artist has stepped back slightly from the front of the canvas and paused, looking forwards out of the picture evidently to fix in his mind what he was currently working on in the painting. The canvas is shown from behind, the painter is looking out of the picture, and is turning the beholder into an accomplice in the picture's effect mechanisms. In this process, a central role is played by the mirror on the rear wall and the metaphors associated with mirrors. The answer to the question of whether the mirror in the background shows the royal couple just entering the room, in the position occupied by the beholder, has been answered in the negative by geometrical analyses. Rather the mirror must be reflecting a detail of the canvas that Velázquez is working on. Even the earliest commentators resolved the problem by deciding that the mirror must be reflecting the painting and not the king and queen in person. The persons in the picture are looking into a mirror and seeing themselves – the theme is an allegory of painting, or more precisely portrait painting, or to use a modern expression, an allegory of the coming-into-being of this picture.

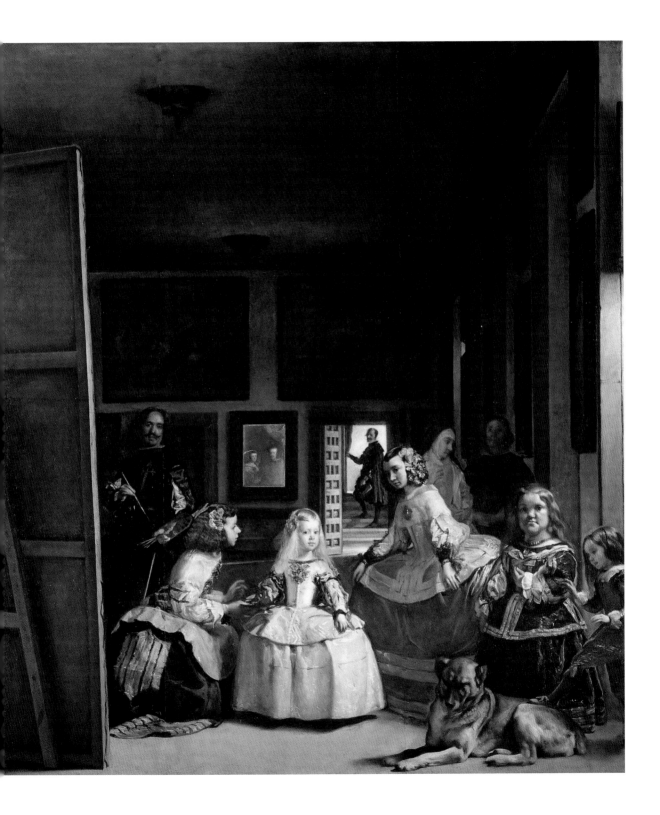

Louis XIV, king of France

Oil on canvas, 277 x 194 cm
Paris, Musée National du Louvre

b. 1659 in Perpignan
d. 1743 in Paris

The state portrait in the *ancien régime* was given a definitive pattern by Hyacinthe Rigaud's portrait of Louis XIV. In the genre of "ruler portrait", this paradigm was used throughout the 18th century with few variations, and was even quoted into the 19th. At first Rigaud's picture was intended as a gift for Louis's grandson, designated to be the new king of Spain. The Spanish throne had fallen vacant at the end of 1700. In 1701, the seven-year-old Bourbon Philip V became king of Spain, and this arrangement promised yet greater political power for France, which finds its expression in Louis's programmatic state portrait.

Louis XIV is depicted standing upright on the dais of a throne, whose canopy, gathered at the top, surges above and around the king. Thus unveiled *(revelatio regis),* his unearthly and superhuman role is revealed. As a young man, he still wore his own hair, but with advancing years he adopted the periwig that was the symbol of ceremonial dignity. The example thus set by the French court integrated the periwig into court ceremonial throughout Europe. This particular version was known as the Fontange, an allusion to the king's mistress Madame de Fontanges. The masses of curls are piled up to create two "horns" and sometimes flow down as far as the hips. The elaborate shape was maintained by a wire frame. The face was added to the picture last, the portrait sittings being limited to the depiction of the king's features.

Louis is wrapped in the blue-and-white ermine coronation mantle, with its golden fleurs-de-lis on a blue ground. Beneath this, he is wearing the robes of the Order of the Holy Spirit, founded in 1578 by King Henry III of France, its Grand Master being the reigning king. Around his shoulders we see the chain of the order, on the star of which is a white dove. The short breeches and the tight-fitting white silk hose also form part of the dress of the order. Where the mantle is pulled up towards the shoulder, we can see the royal arm, the hand on the hip, and the golden coronation sword, which designates its bearer as the rightful heirs of Charlemagne. The hand on the hip holds a second glove, a chivalric gesture which here matches the dancing-master pose, the ideal posture. The leg, moved forward in front of the other, signals the starting position for a dance, but also a consummately graceful standing position.

Louis's right hand is supported on the reversed lily-sceptre, the symbol of executive power. On a plinth are the crown and the second sceptre, the *main de la justice,* the symbol of judicial power. Behind these regalia is the base of a column decorated with reliefs depicting the personifications of *Iustitia* (justice) and *fortitudo* (strength). The double column itself should be seen as symbolic of the union of the two Bourbon states, France and Spain. The pictorial space is closed at the rear by schematic architecture, which has been interpreted as a temple of virtue. In this *portrait d'apparat,* chock-a-block with a whole apparatus of attributes, Louis XIV appears not as an individual, but as a political *persona moralis.*

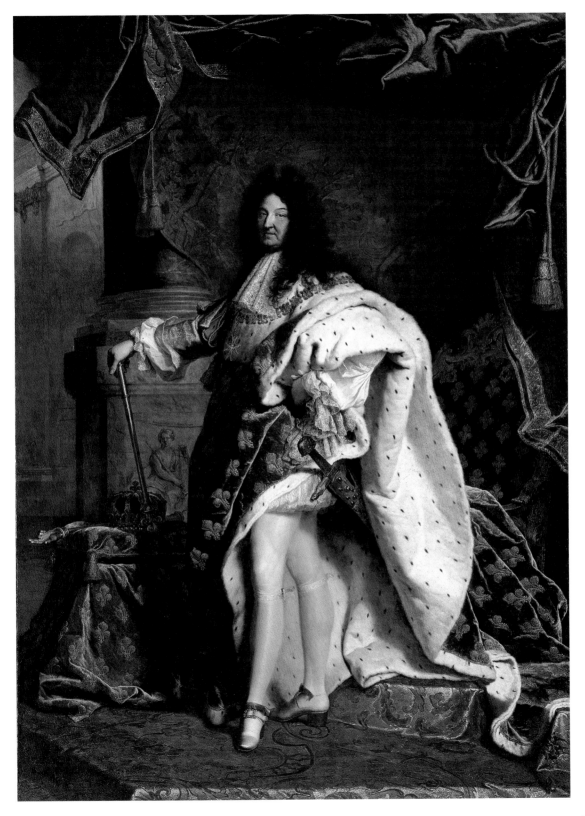

commodore augustus keppel

Oil on canvas, 239 x 147 cm
London, Greenwich, The National Maritime Museum

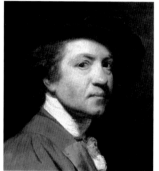

b. 1732 in Plympton (Devonshire)
d. 1792 in London

As a portraitist and art-theoretician, Joshua Reynolds was the leading head of the Royal Academy of Arts in London. As its first president since its foundation in 1768, he was knighted in 1769. Sir Joshua tirelessly promoted a higher status for the portrait as a genre to compete with history painting. His total of fifteen *Discourses on Art* began in 1769 as addresses delivered at the Academy's award ceremonies and continued until 1790. As early as 1779 the first eight Discourses appeared in book form, and made art a topic of public discussion. The portrait was, for Reynolds, the expression of the "grand style" when it was based on artistic exemplars. The depiction of the person should, he said, be subordinated to a "general idea", and the "effect" too should be of "general" validity. For Reynolds, a favoured compositional means was the borrowing of figural motifs from the store of classical and modern art. The "borrowed attitudes" were intended to ennoble the sitter and distinguish the artist as a master who had studied the great works of the past and reinterpreted their inventions.

At an early date Reynolds was already following this "borrowing" maxim. The portrait of Commodore Keppel is in this regard programmatic, and marks the turning-point in Reynolds' career. Keppel was one of fifteen children of the second Earl of Albemarle. After a circumnavigation of the world in 1740, Keppel had a meteoric career in the Royal Navy. As early as 1749, he was promoted to commodore. He invited the young Reynolds to accompany him to the Mediterranean, as a result of which the painter had the opportunity to visit Italy. This study trip was a milestone for Reynolds. The life-size portrait was his thank-you gift to Keppel after their return in 1752. The two remained friends for life. X-ray pictures show that Reynolds experimented with Keppel's pose, and changed it, but from the outset, there must have been the idea to quote the famous *Belvedere Apollo.* Keppel's striding posture resembles the classical statue, but is reproduced frontally. The borrowed pose bears the thought of the idealization of the individual.

The painting shows the supple painting technique of the early works, carefully executed with soft brushes. Keppel is standing on a small strip of shoreline in front of a steep cliff-face. The dramatic scene relates to an event in 1747, when Keppel, following a shipwreck off the coast of Brittany – hinted at in the background – was arrested and court-martialled. The scenery with the storm, the wild surf, the rocky coast and the flickering lightning is in accordance with the aesthetic of the sublime, and enhances the heroic character of the naval officer, who, unimpressed by the forces of nature, poses for the painter. The pose and the landscape idealize the sitter.

When portraying women, Reynolds varied the form of staging. In the portrait of *Lady Worsley,* the gentle scenery conjures up associations with landscape gardens. The lady is posing in riding habit with a feathered hat and a horsewhip in her hand, which Reynolds used to demonstrate the new freedoms in female fashion, while at the same time suggesting a general sportiness. The chief accent is provided by the fascinating effects of the red tones against the greenish-brown background: the painter is advertising his skills as a colorist.

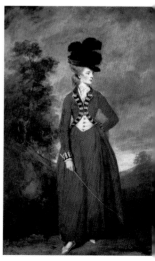

Lady Worsley, 1780

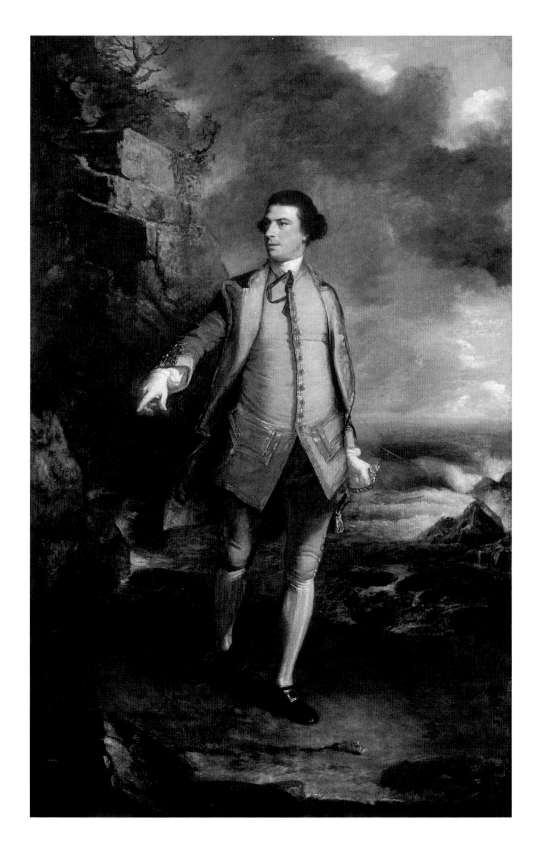

marquise de pompadour

Oil on canvas, 201 x 157 cm
Munich, Bayerische Staatsgemäldesammlungen, Alte Pinakothek

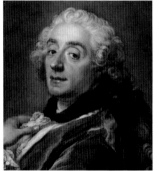

b. 1703 in Paris
d. 1770 in Paris

François Boucher was already an established painter when Madame de Pompadour made him her favourite artist. But it was not until 1765 that he was appointed "Premier peintre du roi", at a time when he was already out of fashion and the subject of vehement criticism. This 1756 portrait is a manifesto of her role of mistress to the king. Mme de Pompadour was born into a bourgeois family as Jeanne-Antoinette Poisson in 1721. By marrying Charles Le Normant d'Étiolles in 1740 she made new social contacts. In 1745 she became the mistress of the French king Louis XV, whom she had met at a masked ball. That same year she was elevated to the nobility as the Marquise de Pompadour. Soon she moved into the mistresses' apartment in Versailles, adjacent to the Grand Appartement du Roi. By 1750 already, Louis XV had turned the relationship into a platonic friendship. There was after all no shortage of fresh, young mistresses. Mme de Pompadour remained the royal favourite, however, with an extensive advisory function and taking all manner of decisions, even regarding alliances and military matters in connexion with the Seven Years' War. In 1752 she was made a duchess, though without exploiting the privileges that were her due. This spectacular social climbing gave rise to envy and resentment, of course, so that she saw herself under permanent obligation to legitimize her status. Because of her bourgeois background, she attached particular importance to gaining respect as a patron of the arts, and at Salon exhibitions, much attention was given to which works she had personally commissioned.

The immediate occasion of this portrait was an important event. On 7 February 1756, Mme de Pompadour was appointed a supernumerary *dame du palais* and given precedence second only to the queen. In the context of this appointment, the dress in the portrait has been interpreted as a *robe à la française* for afternoon wear. To execute the commission, Boucher merely had to draw her head and two hands; he could paint the dress at leisure back in his studio, where clothed a tailor's dummy. There is no doubt that he devoted huge attention to the reproduction of the texture. He presents the duchess i a study on a chaise-longue in front of a large mirror. She is holding a open book in her hand, pausing in her reading to gaze contemplative out of the picture to the left. In front of her is a small table, on whic can be seen a letter, her signet ring and sealing wax, while the drawe is open to reveal an inkwell – all signs of her letter-writing activity.

The whole situation though is oriented towards calculated pri vate ness, the stylized intimacy of a moment of retreat, showing her in terests when liberated from the demands of etiquette. The little dog a her feet is both a lapdog and a symbol of loyalty. The musical scor and the open folder of prints likewise demonstrate, together with th stylus and burin that she herself was an active amateur artist. The ex tinguished candle on the table indicates that she was also in the habi of devoting herself to reading or correspondence at night, so that fo all her noblesse, a certain work ethic is discernible. The *Mercure de France* could hardly restrain itself in its praise for Boucher's painting "What grace! What abundance! What accessories! Books, drawing and other accoutrements point to the inclinations of Madame la Mar quise de Pompadour towards the art and science which she loves an nurtures with success, and to whose study she devotes herself to th best of her ability."

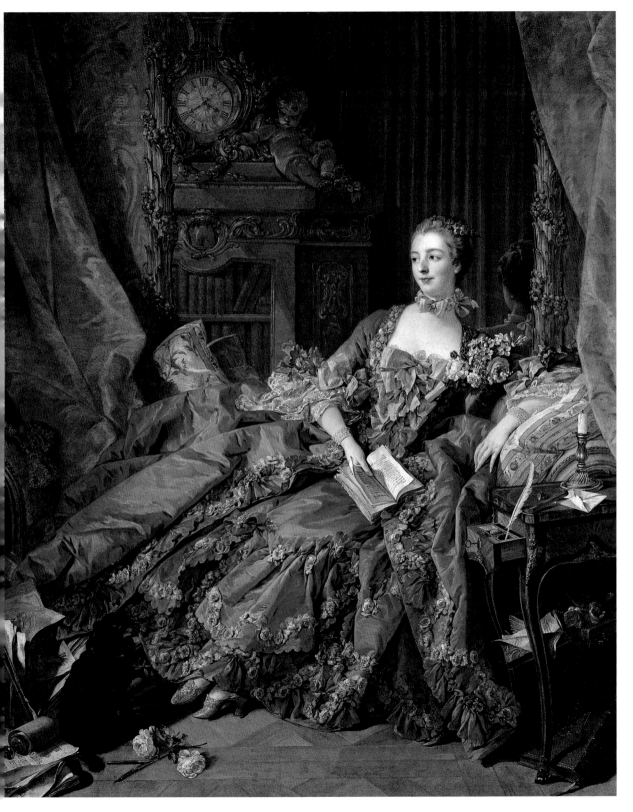

Denis Diderot

Oil on canvas, 81.5 x 65 cm
Paris, Musée National du Louvre

b. 1732 in Grasse (Provence)
d. 1806 in Paris

At the time this portrait was painted, Denis Diderot was one of the most famous *literati* in Paris. As the editor and publisher of the *Encyclopédie,* and author of many articles, novels and pieces of art criticism, he had the reputation of an *homme philosophe.* His competence as a critic was founded on immense reading. From aristocratic Rococo culture to the bourgeois ethic of virtue, his books and articles accompanied the whole of French art production under the *ancien régime.* Various sources report that Diderot was not without a certain vanity in wishing to be portrayed in the guise of the witty intellectual. Fragonard by contrast enjoyed the reputation of a talented painter with a quick brush and an inclination towards gallant themes. As late as the Salon of 1767, Diderot had accused Fragonard of painting boring pictures. The artist seemed to have been only too ready to give himself over to lucrative commissions for pictures of lightweight subjects and amorous *doubles entendres.* It was not for nothing that alongside Boucher he is seen as *the* painter of the French Rococo.

In no way does the portrait, which Fragonard made of Diderot in his inimitable combination of sketch and painting, depict a bored man of letters. Fragonard was concerned to capture Diderot's "esprit" and above all his *génie.* In the Age of Enlightenment, the loose robe was the typical indoor clothing of the intellectual or artistic man. There are allusions to the artist self-portrait in that the robe is worn over an open shirt and the natural hair is shown rather than a wig. The robe and headgear at the same time afforded protection against the ravages of poorly-heated homes. The private retreat was the place where thoughts were produced, the place of creative study. Fragonard followed this tradition and conceived a situation in the scholar's study. Diderot is sitting at his desk in an olde-worlde imaginary "Spanish" costume, leafing through a folio volume. The Spanish costume was regarded as a symbol of gallantry. Whether Diderot liked to dress himself in such getup we do not know. His attention has been distracted from his reading. He is looking over his right shoulder to the left, supported by the gesture of the left arm, as though he had been addressed. The impression of being present at a sudden situation is reinforced by Fragonard's brisk and seemingly casual brushwork, which sketchily engenders an atmosphere of transience.

Fragonard's portrait of Diderot is part of his series of *figures des fantaisies,* which was being built up at this time and depicts people in particularly inspired moments. Diderot himself had, on the occasion of another portrait, demanded the "grace of action". He wanted an action appropriate to the activity of the sitter, one which characterized him. The supreme commandment here was truth and naturalness of presentation. The action and pose were to be demonstrated with natural gestures. The ideal, for Diderot, was solitude in an unobserved moment, and the portrait was to simulate this. And as an unobserved genius in a state of inspired thought-production is also how Fragonard depicts him. This is a familiar enough genre, but Fragonard stages the enthusiasm of literary ideas with his impulsive painting technique and this combines the interest of the sitter with that of the beholder, a central concept in Diderot's theory of art.

"All the points of the canvas say the same thing, each in its own way."

Diderot in his 1765 Salon critique, in which he praised the composition of a painting by Fragonard

Lady Bate-Dudley

Oil on canvas, 221 x 145 cm
London, The Tate Gallery, lent by the Trustees of the Bate-Dudleys 1989

b. 1727 in Sudbury (Suffolk)
d. 1788 in London

Thomas Gainsborough rivalled Sir Joshua Reynolds as the leading portrait painter of 18th-century England. He publicly stylized his opposition in art-theoretical questions, but remained in a good working relationship with Reynolds. Gainsborough had begun his career as a provincial painter in Suffolk by copying landscapes and portraying the landed gentry. From 1759 to 1774 he worked in the society resort of Bath, where a high-ranking, increasingly enthusiastic clientele gave him well-paid commissions. In 1768 Gainsborough was one of the founder-members of the Royal Academy of Arts, and the only portraitist who was not based in London. Still, that was where his exalted clientele lived, and so that was where he moved in 1774, profiting also from the patronage of the royal family.

Lady Bate-Dudley was the wife of the newspaper publisher and art critic Sir Henry Bate-Dudley, who since 1777 had been giving Gainsborough enthusiastic support in his articles. In 1780 he had the artist paint a lifesize portrait of himself in a park landscape. When the portrait of his wife followed in 1787, Gainsborough once again chose the landscape situation, but had recourse to a classical Urania pose. For Gainsborough though, in contrast to his rival Joshua Reynolds, the classical allusion was not intended as a characteristic of the sitter, but to call forth free associations of a general attitude, which does not come across as imposed.

Lady Bate-Dudley is leaning against a garden monument with her legs crossed. The extended index finger of her left hand is touching her temple, a graceful, relaxed pose. In England, a natural form of dress had already by now become usual. Flowing around the body is a diaphanous veil which covers her coiffure. Her hair itself is no longer powdered, while skirts were only slightly "upholstered" and fabrics were allowed to fall loosely and playfully. The décolleté was smaller, the bodice less rigid, and there was only a shawl about the hips. This new naturalness is the hallmark of Lady Bate-Dudley's portrait. Gainsborough creates a virtuoso combination of this natural portraiture and the trees and shrubs of the garden ambience. The ensemble is supported by the interplay of the distant light with the close-up illumination. Lady Bate-Dudley appears as her own source of light in the picture.

This naturalness, fêted by contemporaries, was achieved by Gainsborough through a painting technique which could, if anything, be understood the opposite way, namely as extreme artificiality of brush-stroke, which was so fugitive, so bold in its movement, that it never stands still in the figural. The light is borne by the colours themselves, they shimmer in free strokes on the surface of the canvas as on the surface of the motif. Outlines are dissolved, spatial distances are glossed over. The artist uses colour as a manifestation of light in order to characterize the sitter and to create an atmosphere from pose, landscape and chiaroscuro. Here he proves his worth as a brilliant landscape painter as well as a sensitive observer of people. Gainsborough succeeds in addressing feelings. In the late portraits, in exemplary fashion in the case of Lady Bate-Dudley, Gainsborough demonstrates a naturalness that was highly artistic and precisely for this reason had no successors in portraiture.

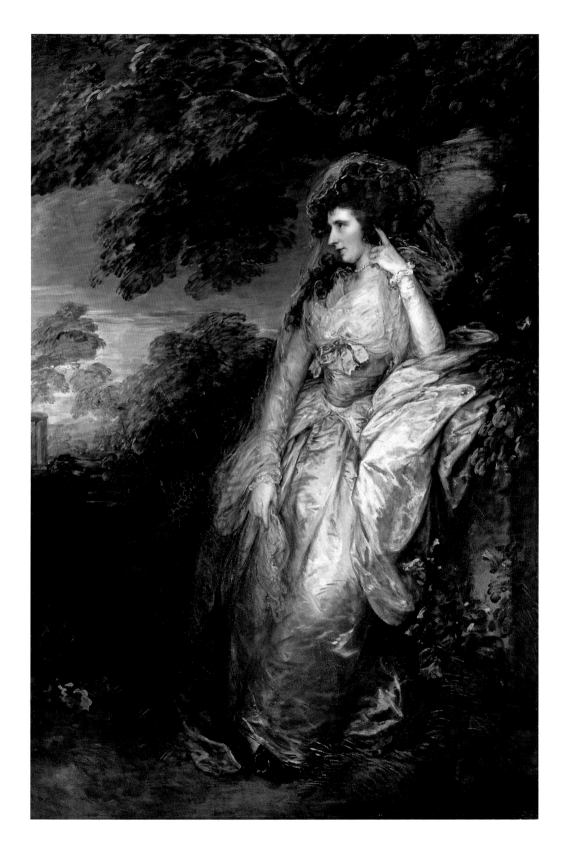

THE DEATH OF MARAT

Oil on canvas, 165 x 128 cm
Brussels, Musées Royaux des Beaux-Arts de Belgique

b. 1748 in Paris
d. 1825 in Brussels

David's painting of the assassinated Jean-Paul Marat became the icon of the French Revolution. The painter had already been the leading artist in Paris under the *ancien régime,* but in 1789 immediately joined the side of the revolutionaries, becoming not only an active Jacobin but their chief artistic ideologue and impresario. In the National Convention he voted for the death of the king. No other painter created images for the Revolution as he did.

Marat's assassination provided the most sensational pictorial event. On 13 July 1793, Charlotte Corday gained access to the revolutionary leader and ideologue by means of a letter in which she claimed to have the names of royalists on whom she wished to inform. Marat was in her eyes a demagogue who with his newspaper *L'ami du peuple* was contributing in a material fashion to the self-destruction of the nation – in her opinion, reason enough for him to deserve death. Because of a skin disease, Marat had to spend many hours a day in his bath, so that the water might assuage the itching. While he was in this bath, she stabbed him. She was immediately arrested and the room sealed off. Just three days later, on 16 July 1793, she was tried, and executed the next day.

On 15 July, at the request of the Convention, David had expressed his readiness to paint a picture of the agitator. He claimed to have seen him just as the picture depicts him: in the bath, a wooden box beside him, on which stood an inkwell next to the scraps of paper on which Marat was noting his last thoughts on the well-being of the people. From the trial documents, however, we know that David manipulated the facts in order to create a propaganda picture for the Revolution and to achieve the maximum pictorial effect.

The room is, because of its neutral colour-background, totally undefined. Marat is sitting parallel to the plane of the picture in a bath hung with a number of towels and covered with a board. His head is bandaged, his eyes are closed, he seems to have expired moments before. Suggestively, David seeks to awaken in beholders the impression that they were witnesses to the deed. In front of the bath is a coarsely hammered-together wooden box, which served Marat as a writing surface. On the floor is the dagger. The deceased seems just to have written something, his right hand is still gripping a quill. In his left hand is a blood-smeared letter on which can be read: "My unhappiness is enough to give me a claim on your benevolence." The assignat represents a charitable donation to the mother of five children.

The composition of the picture is very complex and unfolds an aura of nearness. To this end, David exploits sacred iconography. In his physical attitude, Marat resembles the dead Christ from an Entombment. The stab wound beneath the collar-bone, too, is designed to recall the wound in Christ's side. Furthermore, the bath resembles a sarcophagus. In this ensemble, the simple wooden box comes across as a tombstone with its epitaph À MARAT / DAVID. The deceased thus takes on the status of martyr. David made a sketch of Marat on the spot; engravings of the detail of the head was disseminated throughout France for propaganda purposes. As if all that were not enough, on 15 November 1793 David made a speech about Marat and his hagiographic portrait in the Convention, where it hung until 1795, when it was returned to the painter at the end of the Terror, who, following the downfall of Napoleon, took it with him to Brussels, where he lived in exile as a regicide.

"I thought it would be interesting to show him in the attitude in which I found him, writing for the happiness of the people."
Jacques-Louis David, 1793

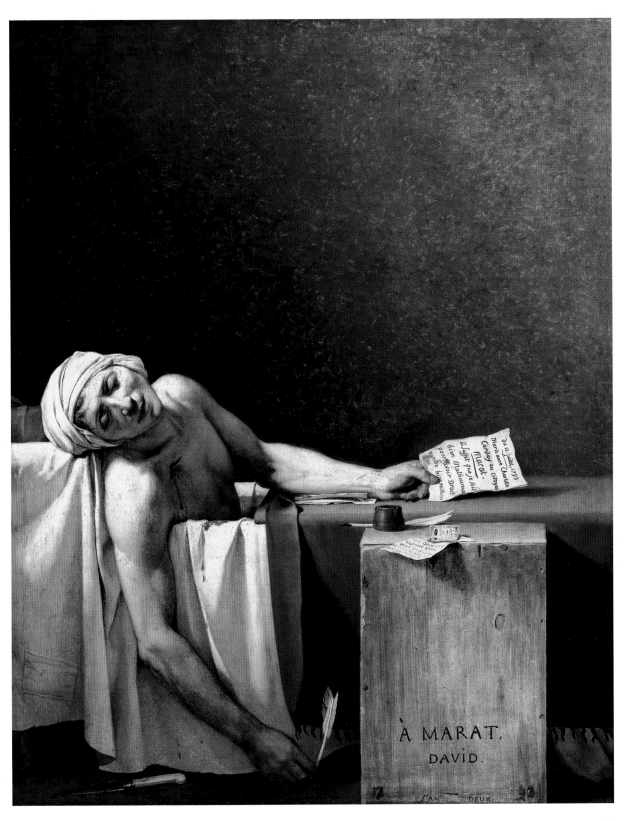

тнe Duchess of Alba in Black

Oil on canvas, 210 x 149 cm
New York, The Hispanic Society of America

**b. 1746 in Fuendetodos
(near Saragossa)
d. 1828 in Bordeaux**

When Goya was commissioned to paint the portrait of the Duchess of Alba in 1795, this was officially to form a pair with the portrait of her husband (Madrid, Prado). However, during the portrait sittings a love affair developed, one of the episodes of Goya's life most shrouded in legend. The Duchess of Alba was, after the queen, the second woman in the state. Consequently, in accordance with her status, Goya painted a full-length portrait against the background of a totally subordinate landscape. In the first portrait, dating from 1795, in which the duchess is wearing a white dress, Goya's aim was to emphasize her rank and her beauty. A conspicuous feature of the portrait is the gesture of her right hand, pointing to the ground, where we see the inscription, as though written with a finger in the sand: "A la Duquesa de Alba Francisco de Goya 1795". This inscription represents restrained homage to a lover, who accepts it thus with her gesture, for Goya leaves open the possibility that she had written it in the sand herself.

The second portrait of the duchess, known as the *Duchess in Black,* painted in 1797, throws off any such restraint. Her husband had died in the meantime (1796), and her affair with the painter was continuing. The duchess was 34, Goya already 50. The picture dates from the year in which this stormy liaison came to an abrupt end. Goya succeeded here in creating a unique document to this affair. He painted the duchess in a black skirt, a golden blouse, a red sash and a black mantilla. He sought thereby to convince the beholder that the colorist effects, above all the nuances of the colour black, had never been painted in a more virtuoso fashion. The technique of the lace hems of the mantilla alone appears as having been wildly thrown onto the canvas with the brush. Goya is at a first zenith of his art. The duchess is standing upright, and is gazing out of the picture straight at the beholder, the first beholder being Goya himself. She has placed one hand on her hip, while with the other she is pointing to the ground, where Goya's signature appears once more in the sand: for the beholder upside-down, but legible to her, are the words: "Solo Goya". There can be no question that the duchess this time wrote the inscription herself, in such a way that she can read it, while, further to the left, Goya has added the date 1797, but this time the right way round, so that we too can read it. The relationship between the two is reinforced by the duchess's rings, each of which bear a name, to wit: "Alba" and "Goya". With these inscriptions, Goya is pursuing an artistic conceit. He knows that his love has no chance, if only because of the difference in rank, and that it cannot last. The pictorial acknowledgement by the duchess – "only Goya" – makes it appear as though she had signed the picture herself, allowing the painter to authenticate it with the date in his own hand. For although the wind can blow away the writing in the sand, the painting can give it permanence, as sealed by the rings. Interestingly, the first word "solo" was carefully overpainted and only much later exposed once more: a retro-confirmation of the affair.

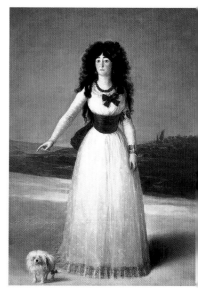

The Duchess of Alba, 1795

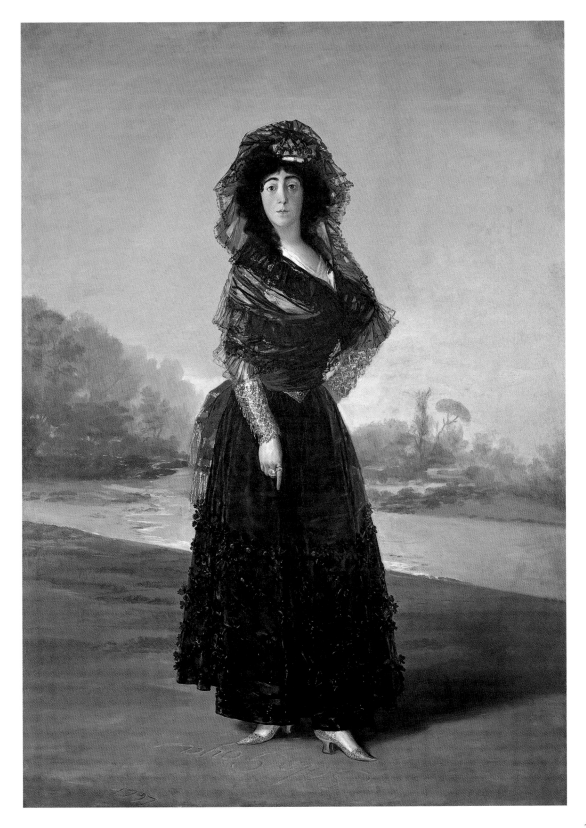

Louis-François Bertin

Oil on canvas, 116 x 95 cm
Paris, Musée National du Louvre

b. 1780 in Montauban
d. 1867 in Paris

Ingres had been professor at the École des Beaux-Arts in Paris for only two years when he accepted this portrait commission from Bertin in 1832. It is not known what led to it, but many anecdotes subsequently sprang up about the invention of this pose. The first said that Ingres almost despaired of finding a telling attitude for Bertin, until suddenly, while they were lunching together, he had a kind of enlightenment. Such inspiration stories are numerous in the history of art and are seldom true. Another anecdote says that Bertin is depicted listening to his sons during a discussion, adopting the pose of a man confident of his incontestable opinions. Whatever: the pose does not so much express a situation actually experienced in a domestic ambience as reflect compositional calculation in the studio. In fact there are extant drawings to prove that Ingres tried out a number of attitudes. His instinct for effective portrait poses ensured he made the best choice.

Ingres portrayed Bertin at the zenith of the latter's career. Bertin, who had grown up under the *ancien régime,* was one of the continent's most powerful newspaper publishers in the early 19th century. His royalist *Journal des débats,* founded in 1799, was banned under Napoleon I. Bertin was exiled, but returned in 1804; however, censorship finally ruined him in 1811. It was only after Napoleon's downfall in 1814 that his fortune changed, and the revived *Journal des débats* became the most influential newspaper among the French bourgeoisie. Increasingly disillusioned by the Restoration, Bertin once more took a critical position, and in 1829 landed up in jail for a journalistic attack on Charles X. Following the July Revolution of 1830 and the installation of the bourgeois monarch Louis-Philippe, Bertin's newspaper became the mouthpiece of the upper middle-class.

Bertin is sitting in a mahogany chair and gazing at the beholder with an inquisitive and critical expression. Bull-like, his corpulent frame, placed at a slight angle to the plane of the picture, fills up the breadth of the canvas against a neutral background, which, by ancient custom, is brighter on the side where the face is in shadow. Ingres has signed and dated the picture top right. The black outlines of the raised shoulders express an energetic assertiveness. An even more penetrating expression of Bertin's self-assuredness is to be seen in the way his hands are planted on his knees, his fingers emerging from his coatsleeves like claws. The total attitude has become a gesture of power. No detail in the picture is neglected, not the short, untidy locks of the man of action, nor the reflection of the window in the polished arm of the chair.

Ingres achieves this by borrowing from the old masters, for example the wideawake faces among the 15th-century Netherlandish painters, or papal portraits since Raphael. Sharpness in the figural details, concentrated in the facial expression, Ingres has succeeded, in the words of an 1833 Salon critic, in creating a masterpiece of form and draughtsmanship. Bertin was a potentate of political opinion-forming, a bourgeois press lord *avant la lettre,* and what Ingres has done is formulate nothing less than the modern pattern of a state portrait without any intention of its being that. The painter has staged a corporeal presence which puts Bertin across as the incarnation of the new, extra-parliamentary power factor in the state, namely the press. Many painters, right down to Picasso, were fascinated by this pose, and took it as their inspiration.

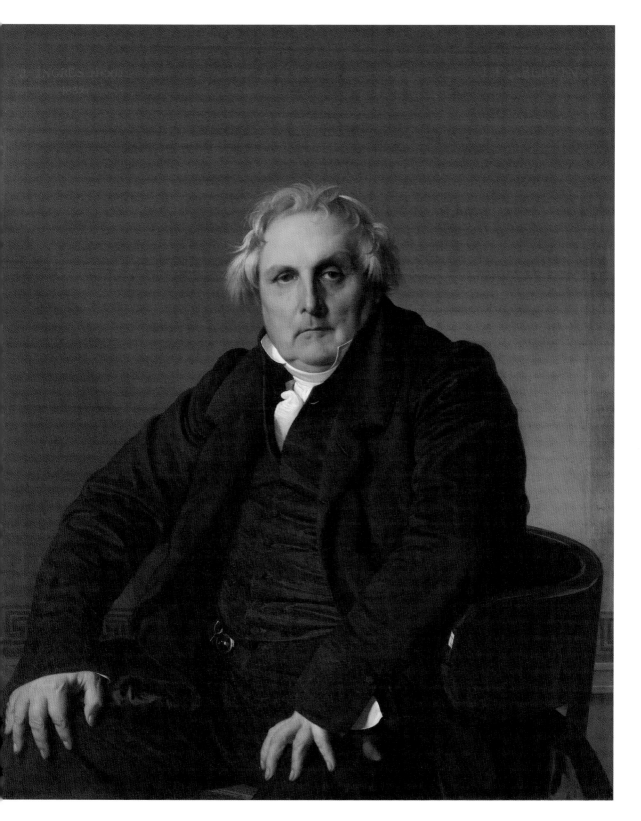

ᴛhe painter's studio

Oil on canvas, 361 x 598 cm
Paris, Musée d'Orsay

b. 1819 in Ornans (near Besançon)
d. 1877 in La-Tour-de-Peilz
(near Vevey)

Two of the eleven pictures submitted by Gustave Courbet for the 1855 Exposition Universelle in Paris were rejected by the jury. They were his two most important, including: *The Painter's Studio. True allegory, describing a seven-year phase of my artistic life.* Angered by this exclusion, Courbet had a pavilion of his own (a shack, more like it), built on the exhibition grounds. On display in this "Pavillon du realisme" were 40 paintings and four drawings by Courbet, which were also offered for sale. Courbet's conception of realism was anything but one-dimensional. Realism as an artistic approach in which the painter depicted only what the eye could see: this was not Courbet's understanding. We are talking not merely about a mimetic translation of natural impressions, for in this case, the studio picture – which purports to be the descendant of the Baroque group portrait – should never have arisen in the first place. Courbet's *The Painter's Studio* does not depict a real situation, but rather it unites individuals and things in a fictional context.

Courbet announced his picture in a letter to his friend Champfleury in 1854. The artist wrote that it dealt with the spiritual and sensuous story of his studio. He had, he said, divided it into spheres, on the one hand the people who supported his ideas, and on the other he himself at his easel together with his most important friends. Sitting reading on the far right at the edge of the picture is Baudelaire. In front of him are a couple in fashionable dress, representing a client with his wife or mistress, and next to them Champfleury sitting on the chair, and behind him further friends and *literati*. On the left-hand side of the picture, entirely isolated from what is going on opposite, are grouped, according to Courbet "daily life, the people, dis-tress, wealth, poverty, the exploiters and exploited, the people who liv off death". Also in this group, which should primarily be seen as a gath ering of symbolic figures, people have recognized contemporarie from the world of politics, right up to Emperor Napoleon III: He is sai to be included as a hidden portrait in the guise of a huntsman, seate at front-left. Undoubtedly, Courbet used this part of the picture as political allegory.

In the middle, finally, is the painter, sitting at his easel working o a landscape. In front of him is a small boy, looking at the work i progress, and behind him a naked model, who was seen even by con temporaries as the personification of truth in painting, as Courbet muse. Truth in painting presented in such abstract terms needs to b related to realism. Courbet's painting-within-a-painting shows a land scape being painted in a studio, in other words not in the presence o the landscape itself. If this is supposed to be the spiritual and sensu ous story of the studio, then to the extent that realism is to be seen a a realism of the picture or of painting, not as realism that depict something real. The *allégorie réelle* would thus be a form of knowing by-looking, and the reality of painting should then be read as the paint ed theory of art. The title of the picture gives the clue that it is a syr thesis of partial pictures, that the reality of painting is an art reality.

> **"ᴛhe description 'realist' was imposed upon me… ɪ wanted quite simply, with the knowledge of tradition, to seek the well-founded and independent feeling of my own individuality. ᴛo know in order to be able, that was my idea."**
> **Gustave Courbet, 1855**

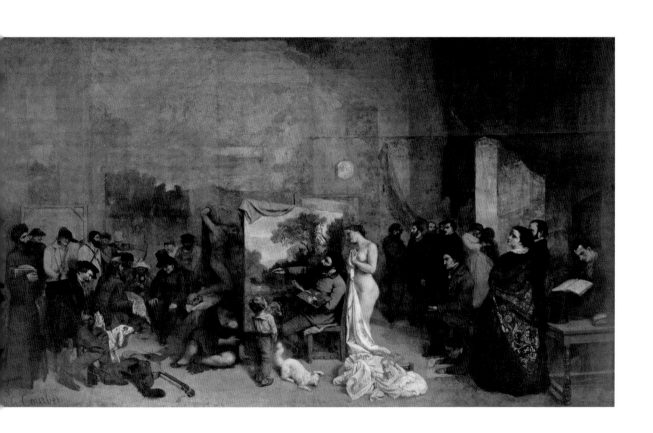

émile zola

Oil on canvas, 146,5 x 114 cm
Paris, Musée d'Orsay

b. 1832 in Paris
d. 1883 in Paris

Manet's portrait of Émile Zola was an homage to an art critic who, on 7 May 1866 had devoted a Salon report of his own to him, even though Manet had not been allowed to exhibit. This was an affront to the jury, interventions followed, and Zola's commission to write further criticism was revoked. Already in 1863, Manet had unleashed an enduring storm of outrage with *Le déjeuner sur l'herbe* (Paris, Musée d'Orsay) and with *Olympia,* also painted in 1863, though not exhibited until two years later. What was scandalous was not Olympia's nudity as such, but the unashamed presentation of a courtesan, who, for good measure, was gazing confidently at the beholder. The young, and at that time not yet famous art critic Zola was however fascinated by Manet's works. There followed a campaign of publicity in which Manet was proclaimed by Zola as the painter of modern life and the sophisticated dandy.

Manet's portrait of Zola was also a return gift, a *quid pro quo* among the avantgarde. For a long time, the painting hung in Zola's billiards room. The art critic and novelist is sitting on a patterned, upholstered chair at a small writing-desk, has his legs crossed, and evidently thinking about what he has just read. His pince-nez is hanging down in front of him, and just as Zola must be seeing the pages of the open book out of focus, so too Manet shows them to us out of focus. The book may be one volume of Charles Blanc's *Histoire des Peintres,* a work in many volumes from which Manet too drew important inspiration. Zola is wearing the fashionable attire of the Parisian dandy, grey trousers and a black coat. On the table we see, on the right, the indispensable pipe, the inkwell and some books. Behind, there is an accumulation of all kinds of utensils, including the blue pamphlet right be-

hind the pen, which Zola published in 1868 under the title *Édouard Manet. Étude biographique et critique.* This painted brochure is at the same time a signature, and Manet's dedication to Zola.

The confined space is closed off by an almost black wall, on which are hanging three reproductions in one frame: a Japanese coloured woodblock print with a sumo wrestler, Velázquez's *Triumph of Bacchus* and Manet's *Olympia.* It is no coincidence that the Olympia in the reproduction, unlike that of the original, is smiling: smiling down on Zola. The reproductions are references to Manet's inspirations for his realism as interpreted by Zola. On the left, the picture is bounded by a decorated golden screen. Manet's composition is very two-dimensional, heavy, and the black would be too dominant if he had not had the colorist skill to contrastingly set it off with pale, mixed, bright hues. In the midst of the calculated arrangement of things and colours, Zola is sitting as though immovable in his study, which, as a space for thought, conjures up the mental kinship between painter and critic.

Olympia, 1863

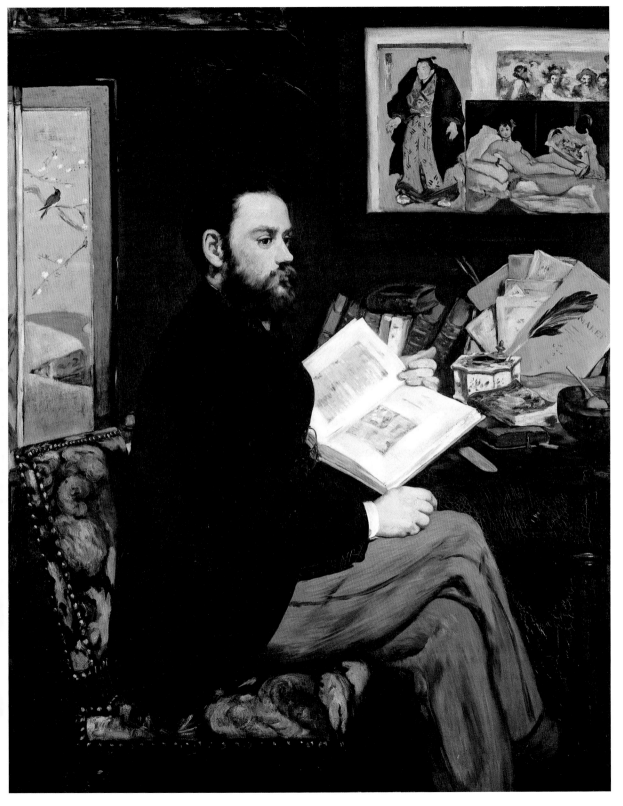

Frau wilhelmine gedon

Oil on canvas, 119.5 x 95.5 cm
Munich, Bayerische Staatsgemäldesammlungen, Neue Pinakothek

b. 1844 in Cologne
d. 1900 in Würzburg

The young Leibl associated many hopes with this portrait commission, in which he had to paint Mina (Wilhelmine) Gedon, the 20-year-old wife of the Munich sculptor and architect Lorenz Gedon. The occasion for the portrait was primarily the couple's wedding. But it was also Leibl's intention to win a medal at the first International Art Exhibition in Munich, and usher in an illustrious career. In her memoirs, Frau Gedon described the three months of sittings as strenuous. Pregnant at the time, she suffered from the painter's moodiness: he could never bring the work to an end, and was always wanting to make corrections.

Finally, her husband put an end to the revisions, declaring the painting complete, and praising it in extravagant terms. The final brush-strokes were executed with a costumed dummy replacing the sitter, who, while understanding that the picture had been admirably painted, found it ultimately not totally successful, as her own reflection in the mirror, she thought, was prettier.

At the art exhibition, the picture aroused attention and was to be awarded a prize, but the jury refused Leibl the medal on the grounds that he was still a student at the academy. Gustave Courbet, who was in Munich at the time, and had made friends with his German fellow artist, encouraged the disappointed Leibl to accept an invitation to Paris. Leibl took the portrait of Frau Gedon with him, and the Parisian public received it with enthusiasm. So it was not in Munich, but in Paris that he received the hoped-for Gold Medal at the Salon exhibition, as well as an offer of purchase that he could not refuse. He persuaded Gedon in Munich to release the picture, and sold it. Only in 1913 did it return to Munich via the art trade.

Leibl had convinced the public in Paris of his skills as a colorist and he was the only German painter whose skills Courbet praised. Frau Gedon is portrayed in a pale ochre raw-silk dress in front of a chair, which is almost lost in the darkness of the brownish-black background. Her head, in three-quarter profile, is slightly bowed, and she is looking out of the picture at nothing in particular. Her hair is tied up with a red ribbon, and around her neck she is wearing her "filigree necklet with red stones", as she herself reported. Her hands are folded over her rounded belly, a gesture that discreetly indicates her condition. Hanging from her lower right arm is a small grey hat, on to which a feather is held by a clasp in the form of a death's head hawkmoth.

It is precisely his restraint in variegation that distinguishes Leibl's painting technique, for he brings out the hues through highly differentiated brush-strokes. Sometimes he creates a dense consistency, sometimes he demonstrates his virtuosity with the most delicate transitions in the chiaroscuro modelling of the fabric. The light seems to fill the materials from the inside outwards, and this radiance also causes the flesh-tones of the face to light up in numerous nuances. In masterly fashion, Leibl uses impasto and streaked colour traces to play off the pale figure of the woman against the dark background of the room. Leibl's colourism reveals first and foremost his study of Rembrandt, with whose late portraits he was familiar, and the Dutch painting of the Golden Age. The role models of old-masterly chiaroscuro painting were crucial for Leibl in this phase of his career. But he provided his portraits with a realism in accordance with the spirit of the age, a realism that sought closeness to reality while creating a subtle artificiality from the sensuous colours.

> **"The famous painter Courbet thought well of me, and I am the only person in Munich who can say this of himself."**
> **Wilhelm Leibl, 1869**

L'Arlésienne (madame ginoux)

Oil on canvas, 91.4 x 73.7 cm
New York, The Metropolitan Museum of Art, Bequest of Sam A. Lewisohn

b. 1853 in Groot-Zundert (near Breda)
d. 1890 in Auvers-sur-Oise

When Vincent van Gogh left Paris in February 1888, he had no firm plan, but hoped for new experiences and dreamt of an artist community, which however was never realized. The women of Arles had the reputation of being the most beautiful in the world, but that can hardly have been the decisive factor for van Gogh. For five francs a day, much too expensive for him actually, he rented a room above a restaurant, only later to move into the famous yellow house. In and around Arles he found sufficient motifs, he mixed with people and took his meals at the station café run by Madame Ginoux. Over the months he portrayed members of the family of the postman Joseph Roulin, including his son Armand at the age of 17. Detailed in the face, with large areas of colour and generous lines in the clothing and neutrally monochrome in the background, the portrait of Armand Roulin is among the works of this period which bring out the dignity of the sitter through the unreal glow of their colouration.

In November 1888, when his friend Gauguin was already living with him, van Gogh painted *L'Arlésienne*, the portrait of Madame Ginoux in traditional costume. She is sitting on a chair at a table, with two books in front of her, and has looked up from her reading. There is nothing else to suggest where she is, the background is a luminous yellow. What brings out the person and things, indeed separates them, are the black contours, which van Gogh uses to mark the boundaries between the colours. This technique of demarcation is known as Cloisonnism, and was employed by Gauguin almost dogmatically in order to demonstrate that he was not imitating reality. Van Gogh was less rigorous, but could be a consistent Cloisonnist in his own way. From a letter written by van Gogh to Gauguin we learn that he executed the oil portrait of Madame Ginoux on the basis of a drawing by Gauguin. Van Gogh understood this as an artistic act of friendship, and swore by the portrait as the synthesis of their joint work over the previous weeks. This work, he wrote, had brought him a month's illness, but he was convinced that Gauguin and other rare human beings would understand it.

The silhouette of Madame Ginoux, sharp in its contours as if cut out, hovers against the spaceless yellow. Everything is pushing into the two dimensions, seeming to approach the beholder. Experience of Japanese coloured woodblock prints is having its effect here, and yet van Gogh is going his own way. The effect comes solely from the two dimensionality of the colour. He achieves vitality through the restless brush-strokes, with which he creates a monochrome frame from inside or out for the objects (books, chair). With an incomparable will to achieve expression through colour, he increases its intensity. The picture is defined by its own value; it is no longer a question of a background, but of the tactile surface tension of the colour, which is applied with a vehemence that draws the eye under its spell. The pictures are not abstract; they reshape reality with the radicalism of their colours, the rhythm of their lines and the composition as an emotional bond between painter and sitter.

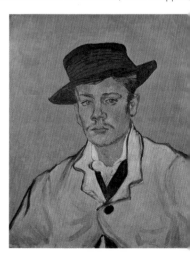

Armand Roulin aged 17, 1888

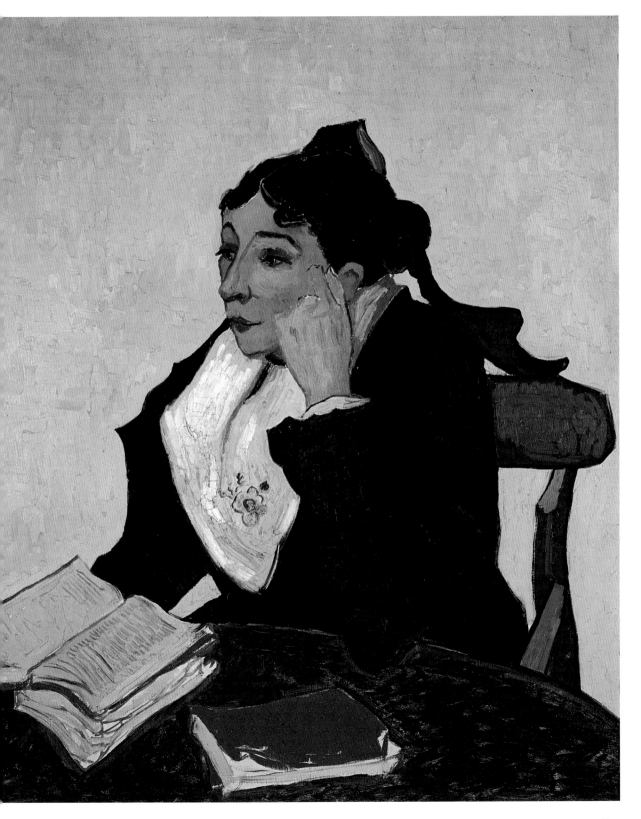

Adolf LOOS

Oil on canvas, 74 x 91 cm

Berlin, Staatliche Museen zu Berlin – Stiftung Preussischer Kulturbesitz, Neue Nationalgalerie

b. 1886 in Pöchlarn (Lower Austria)
d. 1980 in Villeneuve (Canton Vaud, Switzerland)

Oskar Kokoschka was on the threshold of his career when he met the architect Adolf Loos in 1909. They quickly became friends. Loos had already made a name for himself as a cultural reformer and critic of the shallowness of Secession art. Since 1897 he had been getting commissions for re-vamping interiors, and as an architect set out in an opposite direction from Joseph Maria Olbrich and Josef Hoffmann. In parallel with the Secession style dominant in Vienna, there developed a new avantgarde around Loos. The critic Wilhelm Schölermann wrote in 1905: "His style is logic incarnate. His aesthetic the abandonment of everything superfluous." The first high points were the interior of the Kärntner Bar (American Bar) in Kärntner Strasse in Vienna and the publication of the famous article "Ornament and Crime" in 1908, in which he pleaded for a reduction of ornamentation in arts and crafts.

Fascinated by Primitivism, Kokoschka attracted the attention of the Viennese art scene to his work by a "wild", intentionally coarse painting style. The fresh reputation of the "wild man" awakened Loos's curiosity. He became Kokoschka's mentor and procured him portrait commissions by declaring himself ready to bear the cost of any portrait that was not accepted. Loos's own likeness took on a programmatic character as a result. In mid October 1909, he sat for the picture in his apartment. Kokoschka took up the challenge, and the result was a masterpiece. Loos is sitting in a chair, looking contemplatively downwards with his powerful hands clasped in his lap. In spite of the formally correct clothing, with three-piece suit and tie, Kokoschka represents a man whose intellectualism is captured by an ascetic conciseness of the head. The expression on his face is determined by the asymmetric, dark-edged eyes and the narrow mouth. The well-lit face is framed by badly behaved hair, accentuated with restless brush-strokes and scratches. The blue of the background and the brown of the suit determine the basic colour scheme and penetrate the impulsive lines of the contours, folds and light-and-shade zones. All the more does this emphasize the contrast between the large, gnarled hands and the rather small head. Loos and Kokoschka's lifelong friendship grew out of their common interest in establishing a new aesthetic awareness. They convinced their friends and clients with their Expressionist avantgarde and set up a signpost of modernity which many followed.

No less ambitious was the portrait of the critic Herwarth Walden, who was one of the pioneers of modernism in Berlin, organizing exhibitions in many places. From 1910 he published the journal *Der Sturm,* for which he managed to obtain Kokoschka's services, even bringing him to Berlin.

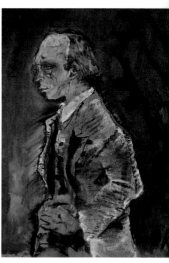

Herwarth Walden, 1910

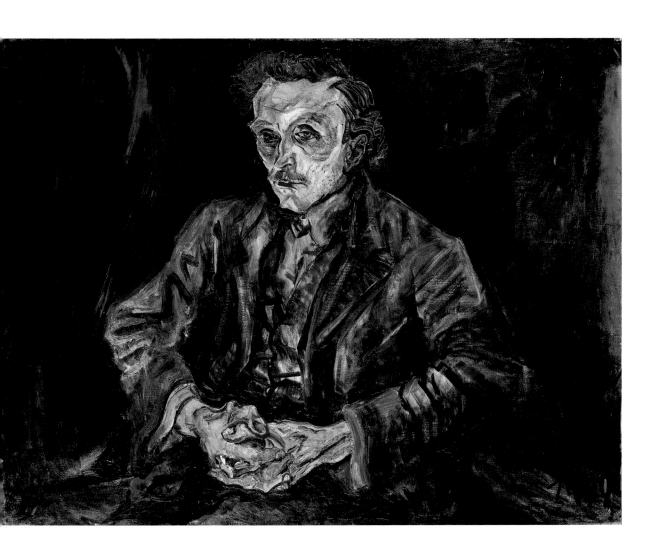

valentine GODÉ-DArel on her sickbed

Oil on canvas, 63 x 86 cm
Solothurn, Kunstmuseum Solothurn, Dübi-Müller Foundation

b. 1853 in Bern
d. 1918 in Geneva

Ferdinand Hodler had only achieved a certain affluence through painting a few years earlier when in 1908 he met Valentine Godé-Darel in Geneva. A Frenchwoman, she became not only his model but his mistress, although he was married. From the numerous portraits which appeared in the following years we can trace a turbulent relationship marked by differences and reconciliations. In October 1913 she gave birth to his daughter. This was followed shortly afterwards why a harrowing story of suffering. Hodler's lover contracted cancer and had to undergo numerous treatments. Hodler captured her terminal illness in an extensive and dense series of drawings and paintings. From the time that the disease made itself known, he drew and painted her time and again: the results can be seen as the narrative of the slow leave-taking. At her sickbed too he drew and painted several dozen pictures, which, as the artistic record of decline could not be more intense. It is not a cycle in whose end we might recognize a new beginning, but an artistic lament with an all too final ending.

In May 1914 another operation became unavoidable. Hodler portrayed Valentine in her sickbed, lying exhausted on her pillows, turning her face slightly away. Shrouded in white blankets, her head is framed by the piled-up pillow as if by a halo. Other spatial indications are sparse. To the right, three red roses project into the picture from a schematic vase. Above them, hovering surrealistically in front of the wall, a pocket-watch shows the time to be shortly after four, but whether it's day or night is not clear. The roses had already appeared in portraits of Valentine in 1912. They were her favourite flowers, and Hodler's symbol of their love. Valentine's profile is turned slightly away from us; she is looking towards the flowers Hodler has brought as if to draw strength from them. Where colour is concerned, Hodler has given the painting a bare-room atmosphere. The ochre wall and the greyish-white sheets contrast with the greyish-yellow face. Hodler has shrouded the patient's weakness following her operation and the emaciated body in these wan colours and underscored the traces of the illness and his own powerlessness with silent pathos.

But after this portrait was painted there was, according to Valentine's housekeeper, a difference of opinion which led to Hodler paying no visits between June and November 1914. Certainly there are no drawings dating from this period. At the end of 1914 Valentine moved to Vevey, to where Hodler once more travelled by express train from Geneva every morning. The disease now progressed rapidly. Valentine died on 25 January 1915; Hodler documented her final five weeks in a further 40-plus drawings and twelve oil paintings. One has to see it as the expression of his own attitude towards death that he portrayed not only the dying, but also the dead Valentine. Just one day after her death he began seven studies of her. In his notebook, he later wrote: "The reason why death, the permanence of immobility, the absolute immobility of language, the permanence of the absence of a sign of life make such an impression upon us is that the beholder of the deceased is aware that he and everyone else must follow."

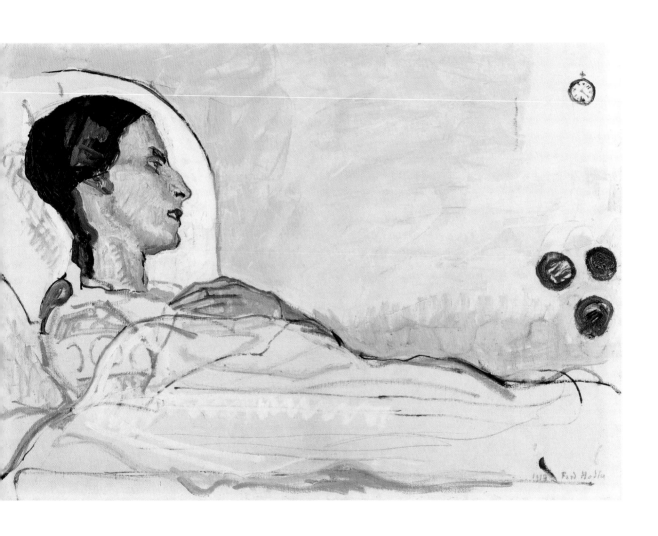

тhe Yellow pullover (Dora Maar)

Oil on canvas, 81 x 65 cm

Berlin, Staatliche Museen zu Berlin – Stiftung Preussischer Kulturbesitz, Museum Berggruen

b. 1881 in Málaga
d. 1973 in Mougins (near Cannes)

The combination of frontal views and profiles was a familiar stylistic device for Picasso from the 1920s on. He had gained important impulses from children's drawings whose childish confrontation with reality inspired him to take a new approach to the dissociation and figuration of the object. What interested Picasso in this was the external form. Dissociation for him meant the union of different views into complex, three-dimensional combinations in two-dimensional space, while figuration continued to pursue depictive representation in associative recognizability. Dismemberment and recompilation had been a path towards figurative abstraction ever since Picasso's pioneering Cubist achievements. But it was not until the mid 1930s that the Spanish artist endeavoured to create ever-new syntheses of figurative-dissociative representations. The aim was the combination of "infantile" formal symbolism and considered, well-proportioned polyperspective. In portraits, in particular those of his lovers, he created several perspectives in one pictorial plane in order to have frontal, side and back views fade and flow into each other. This was to remain Picasso's theme for decades.

In the portrait of Marie-Thérèse Walter dated 6 January 1937, the figural polyperspective is apparent primarily in the face, which is shown in profile, but at the same time gazes at the beholder frontally with both eyes, while the body evinces only defamiliarizing shifts. The transverse lines and the compactly arranged colour fields put her across as a relaxed, stable personality. He had known the then 17-year-old Marie-Thérèse Walter, who became his secret lover, since 1927. In October 1935, after Picasso had separated from his wife Olga Koklowa, Marie-Thérèse gave birth to Picasso's daughter Maya.

Shortly afterwards, Picasso met Henriette Theodora Markovitch. She was 28, a photographer with artistic ambitions, who for years had moved in artistic circles and ran her own studio under the name "Dora Maar". It didn't take long before she became his mistress. She documented the creation of his masterpiece *Guernica* (1937; Madrid, Museo Reina Sofía) in photographs.

From Dora's ambivalence, which fluctuated between ready devotion and the fury of suffering caused by the unsteady relationship Picasso drew the energy to consign her complicated personality to a series of drawn and painted portraits. It would be inadequate to want to see them merely as the record of a tense love-affair. The portraits of Dora Maar have tension, to be sure, but above all in respect of their formal alterability. *The Yellow Pullover* was painted while they were both staying in Royan on the Atlantic coast. Picasso had just (in August 1939) finished another key work, the *Night Fishing at Antibes* (New York, Museum of Modern Art), in which Dora appears as a spectator. In *The Yellow Pullover* Picasso varies his basic scheme of the frontal half-length figure. The knitted pullover is translated into a pattern of polyperspective facets and anchors Dora in the armchair. Picasso does not radically shift the perspectives of the face but dissociates the directions in which the eyes are looking. Dora is looking at the beholder, but at the same times appears withdrawn into herself; the head resembling a plaster bust, is in a wan whitish-grey, from which the red mouth radiates like a signal.

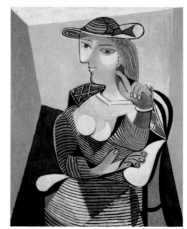

Marie-Thérèse Walter, 1937

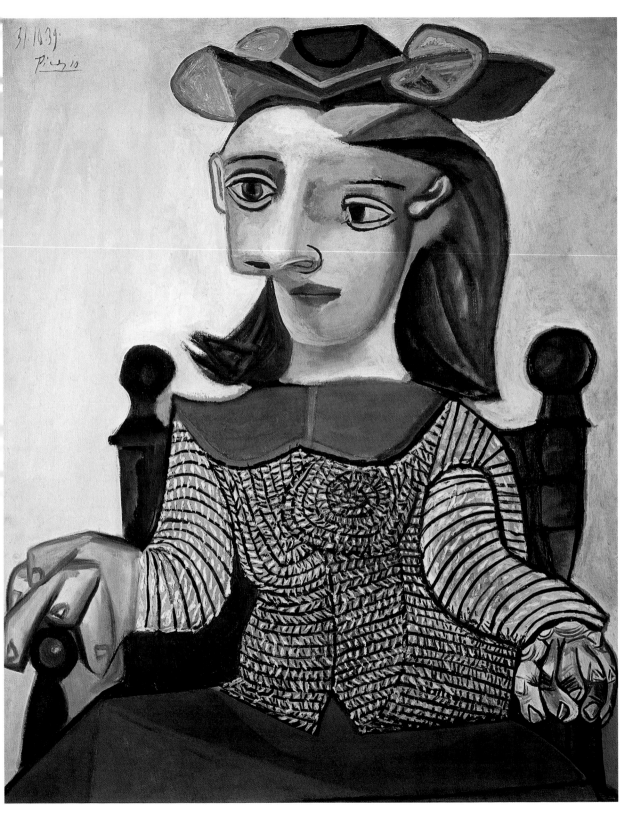

marilyn

Silkscreen print on canvas, 101.6 x 101.6 cm
Private collection

**b. 1928 (?) in Forest City
(Pennsylvania)
d. 1987 in New York**

Andy Warhol was a master of the celebrity cult. He played a virtuoso game with pre-formed perceptions, with images from the realm of the familiar. Already successful as a commercial artist, he succeeded in his breakthrough as a recognized Pop Artist at just the same time, in late 1962, as this name for the art of the new Realism had established itself following a symposium at the Museum of Modern Art in New York. From this year on, portraits played a major role in his œuvre, even though he was not a portraitist in the traditional sense of the word. Warhol sent the first client who wanted to commission a portrait from him into a photo booth. His portraits therefore were based on photographic originals which he revised using multiple techniques.

After Marilyn Monroe took her own life with an overdose of sleeping tablets on 5 August 1962, a sensation industry set about creating her apotheosis. Warhol played an artistic part in this process in his own way. He had just begun to experiment with photographs of film stars when the news of Marilyn's death broke. What was produced now were memorial pictures with iconic status, a transfiguration of the star into a transcendent sphere through the power of the picture. And in doing so, he put his finger on the nerve of popular culture. By pointing to a charismatic life as a star and its moments both tragic and glamorous, the artist directs attention back to the public who generated, fed and at the same time consumed the myth of the star. Warhol had noticed early on this interaction between popular culture and consumerist compulsive behaviour. It was one of the many driving forces behind his art.

The picture is based on a still taken during the filming of *Niagara* (1953). It is an aspect of the star cult that the photograph diminishes

detachment and unapproachability. Yet a nearness, however it comes about, created by the photo always remains stylized, being condensed from one's own desires and fantasies. Warhol was perfectly well aware of this. He cut out the head and had a serigraphic screen made. The first prints on canvas were in black and white, individually or in as many copies as required. Warhol went a stage further and prepared the canvases with patches of colour to underlie the individual parts of the face. Some were larger, in order to factor in the variations that arose as a result of the intentionally irregular printing process. Often the quantity of colorant changed, often the print slipped, but Warhol always accepted the result. Thus all the works, no matter how mechanically they came across, had an autograph quality, an artistic signature. Since the underlying picture is not rejected, but artistically reshaped, an effect is created that a star photo as such can hardly achieve. With *Gold Marilyn Monroe* (1962; New York, Museum of Modern Art) he then indeed exploited the pictorial effect of the icon. He placed a single relatively small Monroe portrait on the canvas and sprayed the remaining surface in metallic gold paint. Hovering over the gold ground like a Madonna, Marilyn acquired an eternal top place in the collective pictorial memory of modern star icons.

Other stars didn't have to die to obtain their Pop image. For Liz Taylor, Warhol succeeded, with *Early Colored Liz* (first produced in 1963) in forming a new personality from the stereotype of mass-distributed star photos. Idols of the silver screen are not famous for being magnificent, but for being famous. Warhol transcended this ideology of the Hollywood dream machine.

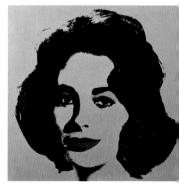

Early Colored Liz, 1963

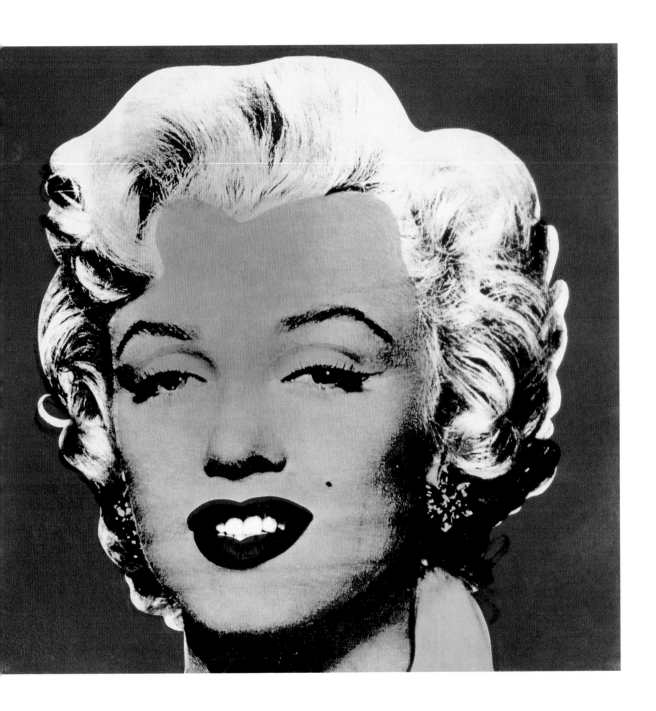

ısabel ʀawsthorne standing in a soho street

Oil on canvas, 198 x 147.5 cm
Berlin, Staatliche Museen zu Berlin – Stiftung Preussischer Kulturbesitz, Neue Nationalgalerie

b. 1909 in Dublin
d. 1992 in Madrid

A turbulent youth led Francis Bacon only gradually to painting: born in Dublin in 1909, he moved to London during the First World War, and it was here as early as 1926 that he had a major split with his father. A sojourn in the wild Berlin of the 1920s followed, after which he returned to London in 1929 – the path to Bacon's artistic career was anything but straight. He had never studied painting at any art college, and the first steps towards exhibiting individual paintings were laborious. Not until he was 40, in 1949, did he have a solo exhibition in London *(Heads)* which attracted any degree of attention. From the interviews with the critic David Sylvester we can learn a lot about Bacon's attitude: "The sitter is someone of flesh and blood and what has to be caught is their emanation." Even as a young man, when it was still a risky thing to do, Bacon had acknowledged his homosexuality. In particular the lust and arousal associated with sado-masochistic practices, and the suffering of sexually stimulating pain, constituted a basic experience for him. He also understood his painting as a painful nervous stimulation. In many ways the distortions, contortions, extremes of expression and defamiliarizations in Bacon's portraits concretize his own temperament and his impulsive manner of transforming everything corporeal into painterly metaphors of fragile human existence.

The inspiration for this portrait of his friend of many years, Isabel Rawsthorne (1912–1992), came from a photograph that John Deakin took of her outside a shop-window in the lively streets of London's Soho district. Isabel Rawsthorne, whose third husband was the composer Alan Rawsthorne, was a painter and stage-set designer. As a model for Jacob Epstein, André Derain, Pablo Picasso, Alberto Giacometti and

Francis Bacon, she had inspired all these artists, since the 1930s, with her temperament, described as exotic and extremely mercurial, to paint numerous portraits of her. She was Bacon's best friend, and by his own account he had even slept with her. The portraits which he painted of her over many years point to an intense personal relationship.

The staging of the picture is based on compositional techniques which Bacon used regularly. The surface of the picture is divided up into a number of colour zones, into which, first of all, the "spaceframe" brings some depth. Isabel is standing within this set of lines in a pose borrowed from the photograph, but showing a montage of different elements. The head derives from other studies that Bacon had painted of her. In three-quarter profile, the basic lines of the face are traced in broad brush-strokes. The expression of the features, colour-alienated in green and white, comes across as almost animal-like. Isabel's body is presented immovably frontally, but the turn of the head, which does not come from the photo, seems to direct her attention to the front of the car and the passers-by. These latter, at least three in number, if not four, are blurred into a mass of colour, and in the brisk brush-work seem to be faster than the car, at the very least conveying a fugitive impression. Bacon's contrasting of the solid forms with clear outlines on the one hand and dynamically blurred colour-fields on the other, serves in this picture too to play off figure and background, surface and volume, against each other, using the medium of colour.

"ʟooking at, say, that portrait you like of ısabel in the street, isn't it really a successful interlocking of clearly illustrational marks with highly suggestive irrational marks, which has some marks serving one purpose and other marks the other purpose?"
Francis Bacon, interview with David Sylvester, 1975

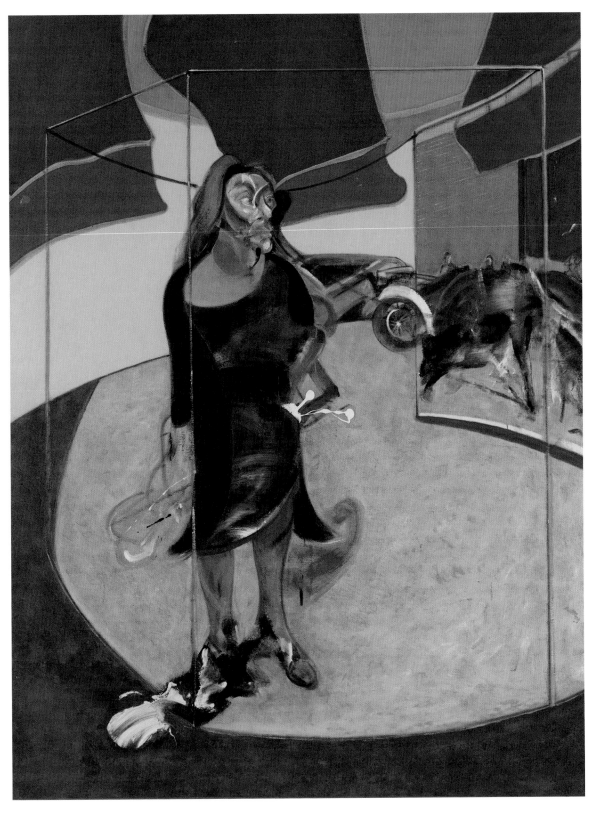

Richard

Acrylic on canvas, 274.3 x 213.3 cm
Aachen, Forum Ludwig für Internationale Kunst

b. 1940 in Monroe (Washington)

During his training, Chuck Close was strongly influenced by Abstract Expressionism, but his dissatisfaction with this style led him, after some experimentation, to a critical confrontation with photography. A self-portrait in 1968 provided the impulse for this decision to devote himself to faces. In the next two years, he painted a series of eight portraits, which were sprayed in black acrylic paint and airbrushed to produce finely nuanced transitions from dark to light. The grid used for the transfer disappeared beneath it. As Close himself confessed, there was a certain theme to these early portraits, which were created in opposition to pop icons. The expression of an anti-attitude to hi-falutin' definitions of art was also intended. As to the portrait of Richard Serra, Close said: "That's exactly the way Richard wanted to look – he wanted to look tough, dumb and ugly." The two had known each other since their student days, and pursued similar goals. Close said of his friend that he wanted to produced the most artless sculpture he could. Close for his part wanted to execute the work with such perfection that it was no longer understood as a work of art, but as a reproduction. This initial rejection of art soon gave way however to his concern to translate the faces from photographs into painting. He once admitted that it was from an on-going love-hate relationship with photography that he got the energy to create an even better likeness in the painting than in the photo. His closeness to Photorealism is obvious, but Close marks the difference by the method of bringing the picture on to the canvas. Until 1979 Close used negative films, and after that large-format Polaroids (app. 50 x 60 cm). What interests him when the picture is taken is how the sitter looks in that fraction of a second. The photograph is then covered with a grid which is then scaled up and transferred to the canvas. Close prefers three formats (100 x 84, 72 x 60 and 36 x 30 inches) though the picture of Serra is 108 x 84 in.

Close soon recognized that the abandoning of colour led to automatism. So from 1970 he turned to colour and began to place primary-coloured dots on the grid. Line by line, the pictorial information is transferred to the canvas. At the end, each portrait bears as its title the first name of the sitter. In his œuvre, however, Close has never clung fast to one technical solution. Since 1977 he has been executing finger-paintings, in which he structures the paint with his fingers directly on the canvas without using a grid.

Close was one of the most radical portrait artists of the 20th century. Rigorously he devoted himself to the theme of the face and thus gets involved in the ancient dispute between likeness and artistic form. The old criticism that portrait painting is nothing but commissioned art designed to flatter, Close has categorically prevented being applied to himself. He accepts no commissions, he does not orient himself to celebrities by photographing them or using their photographs, but portrays only people he knows well, or who come from his immediate circle of family or friends. Personal closeness to, and knowledge of, the person flows into the portraits as an expressive factor. The works convey an intimacy of the individual which cast its spell on the beholder without allowing the slightest hint of voyeurism. The suggestion that one might know these people just as well, or be friends with them, can be readily admitted. But at the same time the illusion of closeness results from the artistic detachment of the technical execution. Close prefers the large format and with the scaling up of the grid achieves the defamiliarization necessary to distinguish his painting from photography.

"The paintings looked more like the people than the photographs did."
Chuck Close

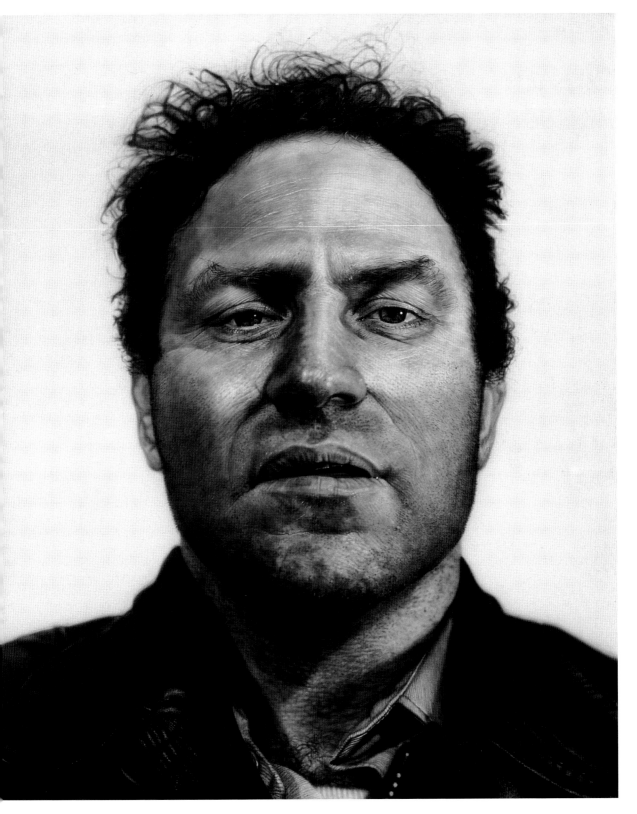

sleeping by the Lion carpet (sue Tilley)

Oil on canvas, 256.5 x 143.5 cm
Private collection

b. 1922 in Berlin

In the long decades of his creativity, Lucian Freud has represented a singular position in figurative painting. He developed a subjective concentration on the human image, for his central themes are the portrait and the nude portrait. One could misunderstand this kind of painting as traditional or hardly avantgarde. But it is the radicalism of the intimacy and its striking translation into brush-strokes which push the old theme of the nude into a new dimension of painterly intensity and lack of compromise. The gaze that Freud directs at his models is obsessive and always interested in the expression of the face and the body of the persons. The sitters are always personally known to him, he does not work with professional models, which is why one can indeed speak of portraits. The completed paintings tell in the structure of their brush-strokes of this directness of the search for a subjective truth of expression. It is also a visualisation of this confrontation by the way that figure and space make a homogeneous statement through colour in order to present the personality of the model. Presentation is one of Freud's central intentions.

Sue Tilley is certainly one of his most imposing models. She was introduced to him by the performance-artist Leigh Bowery, of whom he also painted an impressive series of nude portraits. Her corpulence has given Sue Tilley the nickname "Big Sue", and her job of Benefits Supervisor at a JobCentre has been included in a number of picture titles. As always, Freud is concerned with the sitter's physical presence, which in Sue Tilley's case comes across visually if only because of the massive body. But that alone is not enough, for Freud presents the nude portrait as something unique and special, and gives the sitter thus an individual dignity. For all the intimacy which the exposure of the naked body creates, it is never a humiliating nudity, but a demonstra-

tion of trust – trust in the painter, which conveys itself via the painting to the beholder too.

In *Sleeping by the Lion Carpet* the intimacy is enhanced by the fact that Sue Tilley is depicted (seemingly) asleep, sitting in an armchair with her head in her right hand. At first, or perhaps rather at second glance, it is crucial for the picture's effect that Freud has stretched the perspective of the picture. The painting has been "flipped open" in vertical format, so that the room does not stretch back into the depth of the picture, but piles up on the surface from bottom to top, and the room is stretched upwards. Because the boarded floor is drawn up to the level of the head, the room loses its depth. The carpet with the lions also pushes the body of the sitter forward, optically speaking. Freud borrowed this compositional technique from the old masters. But it serves to enhance the closeness of painter and sitter or beholder and sitter. The massive body hardly seems to have room on the armchair, the flesh piles up, the breasts flow over the belly which in turn flops over her sex. It is difficult to look at such a picture without emotional tension, the moment seems all too indiscreet, hovering as it does at the limits of voyeurism, and making us aware of this. It is, finally, the fascinating impasto brush-work of the colour distribution in the flesh which fetches the eye back from the heights and depths of the naked body to the surface of the pictures.

"Through my intimacy with the people I portray, I may have depicted aspects of them which they find intrusive."
Lucian Freud, 1993

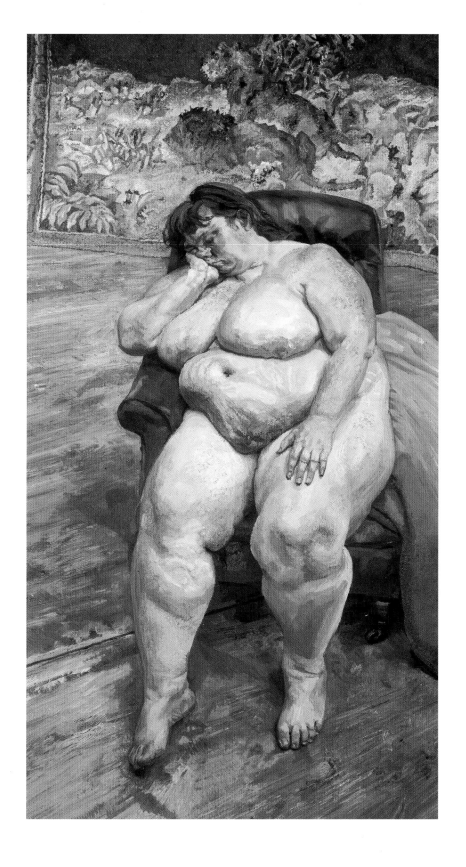

To stay informed about upcoming TASCHEN titles, please request our magazine at www.taschen.com/magazine or write to TASCHEN America, 6671 Sunset Boulevard, Suite 1508, USA-Los Angeles, CA 90028, contact@taschen.com, Fax: +1-323-463.4442. We will be happy to send you a free copy of our magazine which is filled with information about all of our books.

© 2008 TASCHEN GmbH
Hohenzollernring 53, D–50672 Köln
www.taschen.com

Project management: Ute Kieseyer, Cologne
Editing: Werkstatt München · Buchproduktion, Munich
Translation: Michael Scuffil, Leverkusen
Layout: Anja Dengler for Werkstatt München, Munich
Production: Tina Ciborowius, Cologne
Design: Sense/Net, Andy Disl and Birgit Reber, Cologne

Printed in Germany
ISBN: 978-3-8228-5470-9

Page 1
GIOVANNI BELLINI

Doge Leonardo Loredan
1501–1504, oil on wood,
61.6 x 45.1 cm
London, The National Gallery

Page 2
JEAN-AUGUSTE-DOMINIQUE INGRES

Princesse de Broglie (detail)
1851–1853, oil on canvas,
121.3 x 90.8 cm
New York, The Metropolitan Museum of Art, Robert Lehmann collection

Page 4
EGON SCHIELE

The Publisher Eduard Kosmack (detail)
1910, oil on canvas,
100 x 100 cm
Vienna, Österreichische Galerie, Oberes Belvedere